Available Light

Photographic Techniques
for Using Existing Light Sources

Don Marr

AMHERST MEDIA, INC. ■ BUFFALO, NY

Acknowledgements

I would like to thank all of the models, actors and friends who posed for this book. Thank you Dimitri, Evan, Wendy, Lauren, Flora, Liz, Samantha, Valerie, Adrienne, Anna, Rob, Suzanne, Dean, Mike, Autumnrose, Jade, Lindsay, Meg, Rita, Amanda, Luke, Shawn, Erica, Erin, Carolann, Niles, Omani, Tonya, Christine, Paul, Heather, Mario, Virginia, and Scott. You made it fun! There were reasons I chose to photograph each one of you.

I would like to offer special thanks to Jennifer Sliker who encouraged me through the whole process. Jen, your sense of design and photographic eye have changed the way I see the world. Thanks.

Published by:
Amherst Media, Inc.
P.O. Box 586
Buffalo, N.Y. 14226
Fax: 716-874-4508
www.AmherstMedia.com

Publisher: Craig Alesse
Senior Editor/Production Manager: Michelle Perkins
Assistant Editor: Barbara A. Lynch-Johnt
Editorial Assistance from: John S. Loder

ISBN-13: 978-1-58428-255-6
Library of Congress Control Number: 2007942240
Printed in Korea.
10 9 8 7 6 5 4 3 2 1

Table of Contents

Introduction

Curiosity

You are probably a curious person. As a photographer, you are probably particularly curious about the process of making an image. No matter how much control and technique we develop as photographers, we are always a bit surprised at the outcome of every shot. Renowned photographer Garry Winogrand once said, "I photograph to find out what something will look like photographed." That is the joy of photography. You have to enjoy the surprise—and watching how light affects your subject is the biggest joy and surprise. It can make them look important, thoughtful, beautiful, or sad. Light reveals and transforms your subject. The light of the natural world never stops doing its magic. Look out the window; light is revealing and transforming the world around you right now. This book is about the light that surrounds us everyday.

> The light of the natural world never stops doing its magic.

I feel I've always had sensitivity to light (and it's not just from spending too much time at the computer, then stepping out into a bright, sunny day). At around the age of twelve, I remember noticing how different the light looked after daylight savings time took effect. Walking from math class to gym class, the entire school seemed like a different place, but it was only a place an hour different from the previous day. I told a friend about the different light. I think his reply was something like, "Shut up, Don!"

Later that year, at the same school, I did my first experiments with a hand-held reflector. During English class, I used my watch to reflect the sun coming in through the window onto my teacher's face. She didn't appreciate the extra light and scolded me in front of the class. I think she would

have changed her attitude if I had a camera with me and got her a nice 8x10 print from the shoot.

Equipment

You can make great photos with little or no equipment. The only equipment you will need is your camera and your eyes. This is not like other portrait photography books on natural and available light that ask you to use a reflector for every shot. The photos demonstrated in this book are done almost entirely with just the camera and the natural or available light. A collapsible reflector, diffusion material, and white or black cards are used for just a few of the photos. These will cost you about seventy-five dollars if you decide to buy the professional versions. They will be less expensive if you make your own. I do recommend buying a tripod, though. Owning a tripod is a worthwhile investment for your future photographic endeavors beyond this book.

The only equipment you will need is your camera and your eyes.

No matter what camera you are currently using, this book will help you to make better photos. I shoot with a digital single lens reflex camera (DSLR). I like the control I get with depth of field, shutter speeds, different shooting modes, and a variety of lens choices. I recommend buying a DSLR. All of the major manufacturers now sell excellent starter kits (camera body and zoom lens) for around six-hundred dollars.

The goal of this book is to get you to learn how to see the potential of natural light, not to talk about the latest gear. Cameras and equipment come and go, but light is always here. It's in front of us every day, but we rarely stop and *see* it. Seeing brings you right down to this moment in time. It grounds you on the planet, alive and in the here and now—not on some planet of "shoulds" and "coulds" and "I have bills to pay." Seeing light is good for your photography and good for your spirit, too.

What is photography anyway? What is it to you? I always thought it was the perfect blend of science and art—a way of satisfying both my techno-nerdy side and my "I'm an artist" side.

I enjoy buying the latest camera and lenses. I love reading the specs and understanding the newest technology. That's my techno side. But when I go out shooting, the camera, lens, and latest technology don't tell me what to photograph. I have to rely on my own artistic instincts about what feels right. My instincts guide me to notice light. The light then tells me what to photograph.

I think we all have sensitivity to light. We just forgot how to see it. Let's rediscover it!

Real-World Problem Solving

With tons of useful photos, this book will inspire you to see your town and your subjects as if you were seeing them for the first time, with fresh eyes. There are a lot of photo opportunities out there; you just need to see them.

Each chapter presents real-world challenges of shooting with natural or available light. How can I make a great shot in a not-so-great environment? What do I do on a cloudy day? What are my options on a sunny day? Shouldn't I just cancel the shoot if it's raining? This book will answer those questions and more. (The answer to the last question is a definite "No.")

The majority of the example photos in this book are portraits. I am fascinated with how light affects the human face and form. Give me a willing subject, window light, and a camera and I'm a happy man. This book will show you how to make your subjects look their best. The techniques shown will help you succeed in making honest, interesting, and flattering images of your subjects. Some still-life and product images are also included to show the versatility of natural light.

A Challenge

At the end of each chapter, I will offer you key things to keep in mind when working in different situations. Some chapters will also challenge you with projects to take up that will enhance your observation of natural light and make you a better photographer.

Don't expect all pretty pictures in this book. The photos selected will walk you through the problem-solving processes necessary to take good photos. Therefore, there will be examples of an initial setting and the problems posed. There will be examples of common situations that all of us photographers have gotten ourselves stuck in before.

I think we all have sensitivity to light. We just forgot how to see it. Let's rediscover it!

With practice, you will gain confidence to get great shots anywhere, under any lighting conditions. Working with natural light is about using what nature is giving you at that moment. Rather than creating an artificial environment with supplementary lighting, you will use simple techniques to mold natural light into the quality and shape you want for your shot.

Advantages of Natural Light

There are tremendous advantages to shooting with natural or available light. First, it's pre-existing. There's nothing to set up. As a photographer, this lets you shoot more spontaneously. Also, with less lighting equipment around, it's easier for your portrait subject to relax. Keep in mind that less

gear means less time spent thinking about gear, and more time thinking about your subject.

Also, with natural and available light, what you see is what you get. It's easy to see the relationship between highlights and shadows. You can easily place your subject in a setting and see how the light is working with their face and form. This book will show you where to place your subjects and what light will work best for them.

Most of all, working with natural light will get you to think on your feet. As a photographer, every time you shoot you are presented with a lighting situation. How will you make a great photo from that situation? This book will help answer that question and make you more comfortable with the surprises presented to you by natural light. In fact, you will become a better photographer by learning to work with natural and available light. You will no longer feel like you need to have a lot of strobes and expensive equipment to make good shots. It's not about having a lot of light. It's about controlling the light you have. Rembrandt didn't have strobes. Neither did Julia Margaret Cameron.

There are tremendous advantages to shooting with natural or available light.

Becoming a Better Photographer

In fact, reading this book will not only help you to take better photos in natural light, it will teach you the foundations of photographic lighting. The concepts of contrast, light ratios, subtractive lighting, backlighting, light quality, composition, and light direction will mold your photographic technique. You will also learn how to "read" the images of other photographers, whose images you may see in magazines or online. Every professional photograph you see will enhance your knowledge of lighting.

Start looking at your world with fresh eyes. This will be a process of trusting yourself and making mistakes. You need to shoot a lot—especially when your subject is another human being and you want to get that fleeting expression or glance that can make a great shot. And you need to shoot a lot to learn about light. Digital cameras are a great way to learn to light better because they offer instant feedback. Shoot and shoot some more, and don't be afraid to make mistakes. This book will help you understand your lighting mistakes so that you make fewer and fewer of them.

This is a book on technique. When you have finished reading it and have done the projects, you will be a better photographer—technically. Use the techniques presented here to help express your ideas. Good photography comes from good ideas. And good ideas come from staying curious. "I wonder how that will look photographed?"

Overcast Day

The light on an overcast day is completely flat with little or no shadows. Is this a good thing or a bad thing? Don't photography instructors always say that this is supposed to be good portrait light? It's a natural softbox, right?

Well, they were wrong. While your subject may not be squinting from the sun, they are lit with such flat light that they may take on a flat, shapeless appearance themselves. An overcast day will create a hot spot on their forehead and nose, and it will probably give them bags under their eyes, too—not very flattering. Just because everything is lit evenly doesn't mean it will guarantee a flattering portrait. No studio photographer places a huge softbox directly above the head of his or her model and expects flattering light.

Our goal, therefore, will be to give this all-encompassing, all-consuming light some control and direction. The good thing about an overcast day is that the light is consistent. Sometimes you can't even tell where the sun is in the sky behind all of those clouds; 9:00AM looks like 3:00PM. That consistency is an advantage, because you can take your time to shape the light in whatever way you desire.

> The good thing about an overcast day is that the light is consistent.

The following (see page 10) is an image sequence for shooting on an overcast day. In this example, the model stood on the steps in front of a building. The sun was buried behind the clouds above and to the left of the camera position. The light created unflattering results. The eyes became dark and the nose caught excessive light (**1-1**, **1-2**; next page).

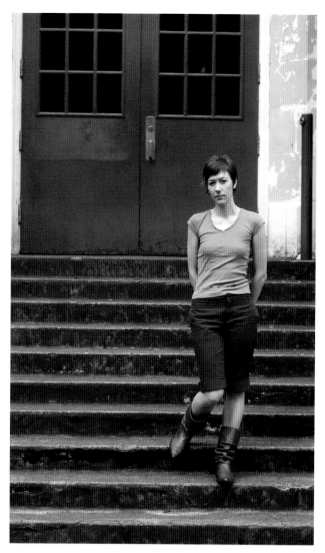

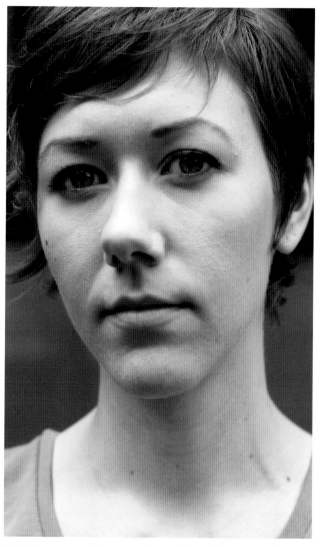

1-1. An overcast day created flat light with no shadows.

1-2. The overcast sky gave the subject dark eyes and produced hot spots on the nose and forehead.

Subtractive Lighting

The first approach to modifying this type of light is to remove some of it; this is called subtractive lighting. By blocking some of the flat light, we can create more directional light, which will give shape to the subject's face.

In image **1-3**, the model turned away from the overcast sky and looked toward the steps, where the camera was now positioned. The dark steps blocked the light from illuminating her face directly. Light was now effectively subtracted from the front of her face, and the light from above and behind her wrapped around her face and framed it. An added benefit of having her turn away from the sky was that the overcast sky acted as a studio hair light (a light placed behind the subject aimed at the back of their head and shoulders). This lightened her hair and separated it from the back-

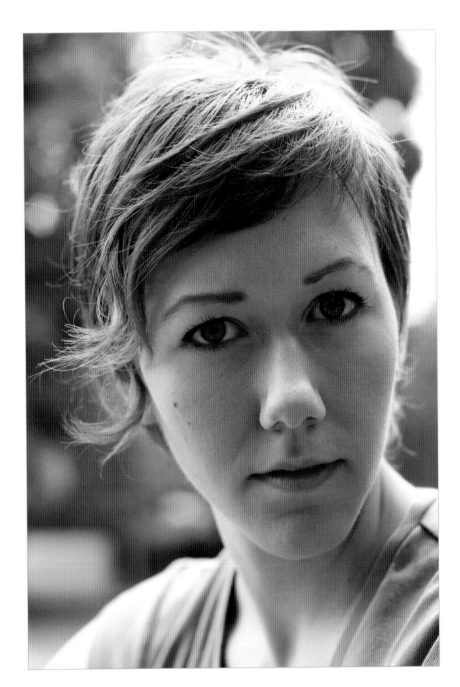

1-3. By having her turn to face the steps, light was subtracted from the front of the subject's face.

ground. (The light catching her nose and darkening her eyes can be improved as well, as shown in the subsequent shots.)

Perhaps the most advantageous aspect of overcast light is that it creates large catchlights in your subject's eyes. Catchlights are the reflections of the light source that appear in your model's eyes. Always be aware of catchlights as you take portraits; the bigger the catchlights, the brighter the eyes appear. For a darker eye effect, minimize the catchlights. There is no right or wrong with catchlights. They are not required to create a successful portrait. Many good portraits have no or minimal catchlights.

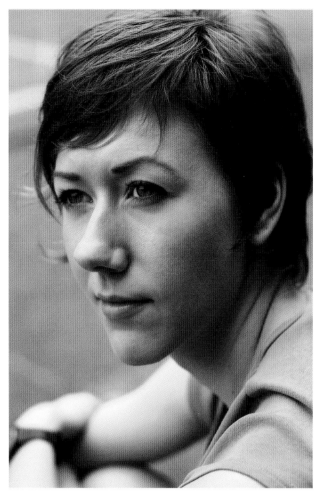

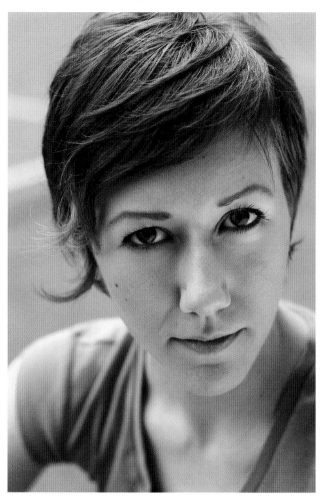

1-4. Use the large light source of an overcast sky to create large catchlights in your subject's eyes.

1-5. A silver reflector was added in front of the subject to create more contrast in the image.

In the next shot (**1-4**), the model was turned back slightly toward the overcast sky, with the dark steps behind her left shoulder. The overcast sky reflected in her eyes, brightening them significantly from the previous shot. The dark steps over her left shoulder continued to subtract light from that side of her body, giving shape to her cheek in a subtle and flattering way. Her nose is now as evenly lit as the rest of her face.

In image **1-5**, a 4x4-foot silver reflector was placed on the steps. A collapsible, PVC frame with silver material stretched over it (available from Calumet) was used here. The model was turned toward the reflector. This created more contrast on her face, as light was reflected from the shiny metal surface. This created more "pop" in the image. Notice that the catchlights are now at the bottoms of her eyes. The direction of the main light source can be established by observing the position of the catchlights in the subject's eyes. This is a great way to "read" photographs and under-

stand how they have been lit. The catchlights reveal the size and direction of the main light source.

The Tunnel of Light

Another way to control the direction of the light on an overcast day is to place the subject in what I call a "tunnel of light." This sounds like a piece of expensive studio equipment, but it's just a term for any location that has an overhang—a doorway, hallway, or anything else that can block the flat, overcast light from above and make it more directional. The further back your model steps under the overhang, the more directional the light becomes (for more on this, see pages 20–22). Because the size of the light source is reduced relative to the subject, it also becomes a harder light source with more contrast. Feel free to use the term "tunnel of light" with your friends and family. Doesn't it sound more interesting to say that you were shooting all afternoon in a tunnel of light than underneath a pedestrian bridge?

Short Light

To create image **1-6**, the model stood in the foyer of an apartment building. It was a small space, about 8x8 feet, with light-colored walls. It was a rainy day and overcast daylight poured in from an 8-foot wide, 10-foot high archway to the right of the camera. The walls of the foyer bounced a subtle amount of light back onto the shadow side of the model's face. In essence, the effect created is similar to using a large studio softbox with a small amount of fill light from a reflector. Explore your neighborhood. The whole world is your studio!

The direction of light created in this image is classic Hollywood short lighting, used in countless movies—and usually in romantic scenes. Soft light comes from slightly behind the model to light the side of their face that is further from the camera (the "short" side). The front cheek is lit, but the

1-6. Soft light came from slightly behind the subject, creating a classic short-light look.

front ear remains in shadow. This lighting direction shapes the front cheek nicely and casts beautiful light in the subject's eyes.

Image **1-7** is a variation of the last shot. Instead of soft light coming from slightly behind the model on one side only, it now came from two sides. The model faced a doorway while standing under a long archway connecting two buildings. This was like a tunnel with the sides opened to the sky—an excellent "tunnel of light" location. Overcast daylight wrapped

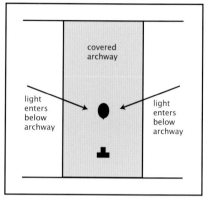

Diagram 1.

1-7. Soft light from the rear wraps around the subject's face.

1-8. Overcast light was subtracted from the top and sides of the subject.

around the side of her face to shape her cheeks. Since she was standing close to the building she was facing, the light only partially wrapped around the front of her face. If she had stood further back in the archway, closer to the far building, the light would have come more from the front. A long archway like this can be effective in creating a variety of looks.

Pre-Existing Studios

Here's another secret "tunnel of light" location. In fact, you must be sworn to secrecy if I give this information to you. Maybe we should form a secret Tunnel of Light Society (TLS? The Tunnelers? Maybe the Mole People?). This spot exists right under your nose in your local park. It usually has a theme and lots of kids around. Yes, it's the jungle gym.

The next shot (**1-8**) was actually taken beneath the rope bridge at a pirate-themed jungle gym. Overcast light spilled over the back of the model to light her hair, while the light from the front created flattering catchlights in her eyes. Thinking in subtractive light terms, the light was subtracted from above her head and from her left and right side. An added benefit to the jungle-gym experience was that the ground was covered with wood chips, which created a warm bounce light from below the subject. Feel free to use this location—hey, you might even want to photograph an actual kid there.

The next two shots (**1-9, 1-10**; next page) were done under an overhang at the entrance to an office building. The entrance was white concrete, making it much like shooting inside a big white box. The corners and walls of the entryway effectively flagged parts of the overcast sky to

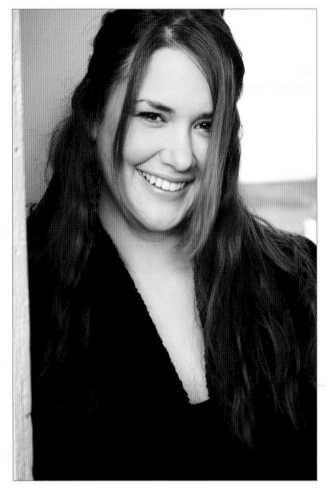

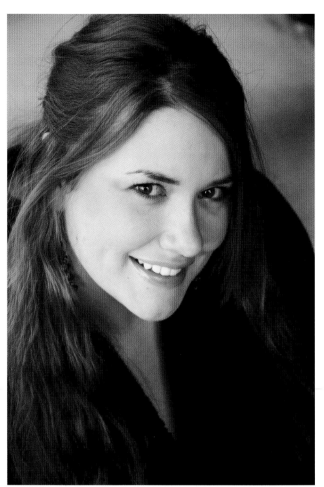

1--9. Columns work well to subtract light and give it more direction.

1-10. The light-colored concrete effectively bounced light into the shadow side of the subject's face.

keep it more directional, from the front and rear only. On an overcast day, look for areas where the light can be partially blocked.

For the first shot (**1-9**), the model stood against one of the columns. The column and the overhang blocked the light to camera left and overhead, which, in effect, directed the light to come mostly from camera right. This created nice shading on her face and the top of her head.

For the next shot (**1-10**), the model sat on the white concrete floor in the same office entrance. Light bounced all around the "big white box." If she had been sitting in a darker area, with the walls and floor painted gray, then the shadow side of her head might have been much darker. The light-colored concrete here effectively filled in the shadow side of her face. The light was still directional, though, since the overcast sky shone through the opening to the building at camera left.

Leaving the suburbs and heading downtown, you can find many locations to set up your next makeshift studio. Parking lots, alleys, and lobbies

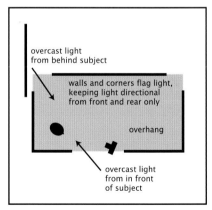

Diagram 2.

are great tunnels of light. Please be aware about photographing on private property, though. You may want to stick to public buildings, such as libraries and public parking lots. Even then, don't be surprised if a security guard asks you what you are doing. If you are asked to leave, don't worry. There are plenty of other locations.

This photo (**1-11**) was *not* done in the studio. It was taken at the street-level exit of a parking-lot stairwell. This is basically the inside of a giant gray concrete box with the right side open—very similar to the last shot.

1-11. A parking lot staircase functions perfectly as a tunnel of light.

The space measured about 10 feet square and the model stood five feet in from the opening. The overcast sky once again acted much like a large studio softbox placed to camera right. The gray walls helped bounce enough light in to fill the shadow side of the model's face.

Here is another high-tech studio setting for the tunnel of light: a freeway underpass! This image (**1-12**) was shot on an overcast day. I shot from a low angle about halfway back into the underpass. Accounting for all of the bright backlight and how it would affect my exposure, I used a center-

1-12. A freeway underpass blocked the light from overhead, keeping it directional from the front and back only.

weighted metering mode to obtain the correct exposure on the subject's face.

Image **1-12** was taken to show the light source for image **1-13**. See that big triangle of white light behind the model where the underpass opens up to the daylight? There is another one of those behind the camera position. This is the light source—basically a huge triangular softbox, as seen in the triangular catchlights in his eyes. A soft but directional light has been created (or found) just off the Main Street exit.

1-13. This is what overcast daylight looks like when all of the light from above is blocked. It's soft yet directional light—great for portraits.

These types of pre-existing studios are everywhere. You just need be on the lookout for them. The only difference when shooting this way is that you will have to position your model to catch the light, whereas when you are in the studio you can place the light to catch the model. Since the light is fixed outdoors, you may have to adjust the angle of your model's face or body position so that the light is hitting them where you want. There's no need to rush, though; you will have plenty of time to work with the consistent light on an overcast day. Anyway, your models will feel like they are having a more active roll in the shoot if you bark out instructions—"Chin up!" "Chin down!" "Eyes up!" "Head left!" "Relax your teeth!" (That last one always confuses them.)

Controlling the Quality of Light

The next image sequence shows how the quality of light can be changed by placing your subject outside, just a bit inside, or far inside the tunnel of

1-14. This is the classic overcast day look. The subject has dark eyes with bags. There are also hot spots on the nose and forehead. Not good!

1-15. Moving the subject under the overhang of the porch made the light more directional from the front.

1-16. The subject is even further back, just inside the doorway. The light becomes even more directional from the front.

1-17. Light from an open door becomes higher in contrast as the subject moves further away from it.

light. These shots were taken on a partly cloudy day. There was some blue sky showing overhead, but clouds obscured the sun at the time the photographs were taken.

For the first shot (**1-14**), the subject stood on the front lawn at the entrance to a house. The overhead soft light made his eyes dark and gave him the notorious bags under the eyes that always result from an overcast day.

For the second shot (**1-15**), the subject was moved back about ten feet to sit on the steps of the front porch. Since the porch blocked a lot of the overhead light, the light became more directional from the front. You can see that there is less light on the top of the subject's head and his eyes are more brightly lit.

For the next shot in the sequence (**1-16**), the subject was moved even further back to stand about a foot inside the now opened doorway. The light came entirely from the front, but it still remained soft. The eyes received much more light than in the previous two shots. Note that the interior walls of the house were several stops darker than the subject, being

ten feet from the open door light source. Only a window in a back room is visible in the image.

For the final shot (**1-17**; previous page), the subject moved further back (another eight feet) until he was completely inside the house. The light source was still the open front door. However, because he was further away from it, the light source was smaller in relation to him. Notice the increased contrast in the quality of light that this distance created. A smaller light source produces harder light and higher contrast. Also, when compared to the previous shot, note that exposure of the room itself has changed in relation to the subject. Since the subject and walls are about the same distance from the open front door, they both receive the same exposure.

It's up to you to decide which of these setups would work for you and your subject.

So which is the best shot? It's up to you to decide which of these setups would work for you and your subject. Some faces look better with very soft light. Others look best with a harder, higher contrast light. You could also try this same series with your subject turned 90 degrees to the light to create soft or hard side lighting. It's all just light from an overcast day and you can control it.

Projects

Shoot a progressive sequence of portraits of a friend on an overcast day.

1. Do the ugly shot. Position your subject directly under the overcast sky to give them the sunken eye look. It gets better from here. We just need a starting point.
2. Subtract the light from above by flagging it. Either place some opaque material above your subject or move them under an overhang—a doorway or anything that will block the light from above. This will give the light direction from the front.
3. Add a silver reflector from below your subject to lighten their eyes, create catchlights. and add overall contrast to the image.
4. Move your subject further back under the overhang so that the light source becomes smaller in relation to them. This will result in higher contrast.

Sunny Day

Bright sun is a welcome sight on the day of a portrait shoot. It offers many possibilities for different qualities of light, including direct sunlight, bounced sunlight, diffused sunlight, or shade.

Quick Fixes for Bright Sun

This sequence will show you some quick and easy fixes to get better shots in bright sun. We've all taken this kind of shot before (**2-1**). It's a bright, sunny day and our subject faced the sun. She had to squint, there are unflattering shadows on her face, and the light is very high in contrast, which made her skin tones wash out.

A quick fix is to turn your subject around so that the sun is at their back. The contrast is instantly reduced, giving better skin tones (**2-2**). The sub-

2-1 (left). The subject faced the sun. The noon sun created harsh shadows and the subject had to squint, as well.

2-2 (right). The subject with her back to the sun. Now there is lower contrast, better skin tones, and no squinting.

ject doesn't have to squint anymore and the sun on her shoulder acts as a nice hair light to brighten her hair.

Another quick fix for working with bright sun is to move the subject to open shade. Open shade is a shaded area in close proximity to a sunlit area. In this case (**2-3**), the girl reclined in open shade just outside the sunlit grass area in the foreground. A small piece of white foam core was placed on the ground in the sunlight, just out of camera view to the lower left. This helped to bounce light up into her face. There are also nice catchlights in her eyes as a result.

> Another quick fix for working with bright sun is to move the subject to open shade.

In image **2-4** you can really see the two light sources at work. She was posed in the shade, looking up to the tree above her. The open shade lit her face softly from above, as some sunlight passed through the tree branches. The patch of sunlit grass in front of her acted as a fill source, bouncing light onto her chin and neck.

Image **2-5** is similar to the last one. The boys were sitting in the shade of a tree as spots of sunlight dappled the grass around them. A large area

2-3. The subject in open shade with a white reflector on the ground in foreground, just out of camera view.

2-4. The subject was posed in open shade with some soft sunlight passing through tree branches. The sunlit area of grass also bounced light up from below.

2-5. This is very soft open shade light. The boys sat just outside of a sunlit area. An open sky plus light bounced from below makes for very soft light.

of sunny grass was at their feet, just out of camera view. This sunny area acted as a fill to bounce some light up into their faces. Open shade light can be made to look softer or harder. The light will be softer the closer your subject is to the sunny area. And the light will be harder, or higher in contrast, when the subject is further away from the sunny area. In this shot, the light is very soft, because the boys are sitting very close to it.

Some Ideas on Photographing Children

Chasing them down, catching them, getting them to sit still and then coercing them to act natural . . . "photographing children" almost seems like an oxymoron. We're just lucky to get glimpses of them in the viewfinder before they run off. So how can we get a nicely lit portrait of that which re-

fuses to be photographed nicely? The answer is: photograph kids in open shade.

What do kids like to do? They like to play. They like to be active. Isn't this the best way to photograph what a kid is really like? Open shade is great for photographing children, since it illuminates a large area. With open shade, limited spaces or tight lighting setups do not restrict you as they would in the studio. Letting kids play and run around also will get them tired so that, if you decide to shoot a posed shot, they will be calm to sit for you. A large, open-shade area offers a lot of space and consistent exposure.

A large, open-shade area offers a lot of space and consistent exposure.

Some kids love the attention of the camera. They feel comfortable being photographed, but they can also tend to ham it up a bit too much with silly faces. I say go ahead and shoot the silliness until they get tired of it. Then you can get them at a more relaxed moment. It might also be a good idea to take the child a short distance away from their parents, who can tend to act a little too much like a director with distracting coaching like, "Don't make that face!" and "Your shirt's untucked." Fewer distractions are better.

Other kids are shy around strangers and tend to hide when a camera is nearby. Working with these kids requires being patient until you gain their trust. Maybe some playtime together—before you even bring out your camera—will relax them. Another approach may be to present the session as a project that you and the child can work on together. Let them see the images on your monitor and maybe even let them take a picture of you (having your camera mounted on tripod would be wise!).

Keep these things in mind when photographing children:

1. Get down to eye level with kids.
2. Shoot in an open area where kids have room to move.
3. Give them an activity to engage them.
4. Shoot a lot of frames.
5. Look for areas with consistent lighting. Open shade is best; backlighting works well, too.

Shadows and Color

The sun creates distinct shadows and rich color. So why not use these to your advantage? Distinct shadows can add a storytelling element. Bright color is always visually interesting, too. Look for strong color contrast to give your shots some punch.

This shot (**2-6**) illustrates both of these ideas. It might be considered incorrect in typical portrait terms—it's super high in contrast, there are lines on his face, and his eyes are dark with almost no catchlights—but it's still a good shot, because the intensity of the lighting adds to the intensity of the subject. This is when your lighting can be taken to a higher level. Match the quality of the light to the subject you are photographing. I wouldn't photograph a baby with this kind of light (I would use soft window light), but for this athlete a high-contrast look works well.

2-6. Use sunlight to create high-contrast, colorful portraits.

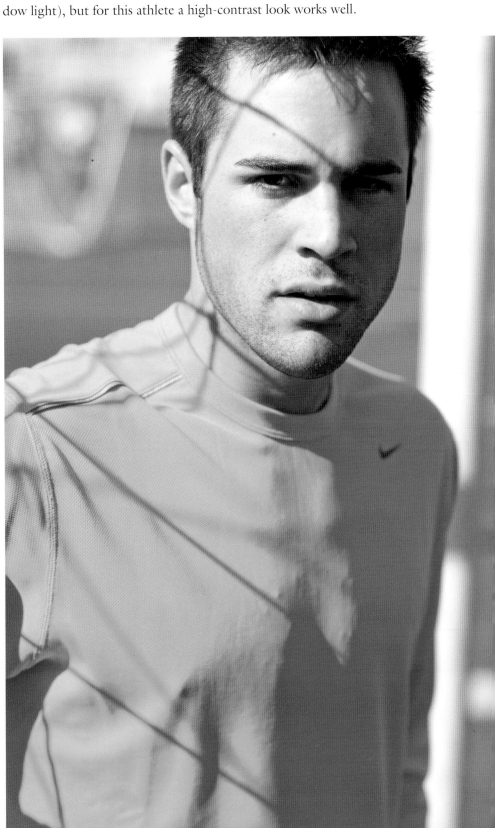

Open Shade: Many Possibilities

These two shots (**2-7**, **2-8**) were created in an alcove near the parking lot at a mall—glamorous, I know. The sun bounced off the pavement to the right of the camera. To the left of the camera was a dark doorway. The light on her face was coming strongly from the side and below. This is the first type of open-shade light: open shade side lighting. You really can't lose with this kind of light. It's soft and directional and provides flattering results for most subjects. There is a nice light ratio (difference in exposure) from the light side of her face to the shadow side.

Here is an important aspect to keep in mind: The open-shade area you choose to shoot in will have an effect on the color temperature (see the primer on page 31) of the shot, especially in the shadow areas. By setting your white balance to the shade setting on your digital camera, you will be able to correct the cool color temperature of open shade to a more neutral color. The camera will correct for the light, but it won't correct for the environment that your subject is standing in. In this shot, the warm-colored walls helped to keep the shadow side of her face warmly colored. If these walls had been blue, however, the shadow side of her face would have had a definite cool color cast.

2-7. Here, we see open-shade side lighting. The warm-colored walls helped maintain a nice skin color on the shadow side of her face.

For the next shot (**2-8**), the model faced the dark doorway with her back to the sunlit pavement. This created the second type of open shade light: open-shade backlighting. This type of light creates a nice wrap of light around the edge of the subject. It can be difficult to meter this type of light, though.

This strongly backlit situation, with all of the sunlight bouncing off the pavement behind her, fooled the camera's meter. It chose an average exposure to try to tone down all of that bright light, which resulted in underexposure on the model's face. To correct for the underexposure on her face, I set my camera's metering mode to spot metering. I took a few test shots to assure that this technique gave me a correct exposure on her

face, noted the exposure, then turned the camera to the manual mode and shot at the noted exposure. This way, if I composed a shot where the subject was not completely centered, I could still be assured of a good exposure on her face.

In backlit situations, use spot metering, initially, to meter your subject's face, but shoot in the manual mode. Then you can step back and choose the composition you want without worrying about the backlight affecting your exposure. You can be assured of a correct exposure on your subject's face even if you decide to off-center them in your composition.

For the final shot (**2-9**), the subject's face is correctly exposed and the background is overexposed to white. The white light from behind wrapped around her face to frame it nicely. There was another feature in this glamorous mall alcove: a recessed light in the ceiling. I had her stand under this light. This lit her hair on top and helped fill in the light on her face a bit.

2-8. Strong backlighting fools the in-camera light meter. It tries to average out the exposure, resulting in underexposure on the subject's face.

2-9. This is open-shade backlighting. The subject's face was correctly exposed using spot metering.

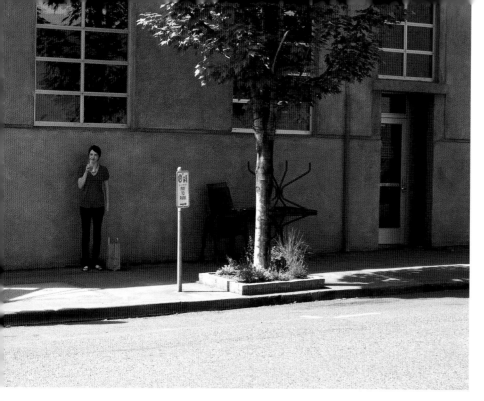

2-10 (above left). A warm-colored wall, a large area of sunlit pavement, and open shade—a good combination for portraits.

2-11 (above right). The result is a soft, directional light with warm shadows and catchlights to brighten the eyes.

2-12 (left). Note how the two different color temperatures affect the subject's hair color. The color within the open-shade environment can definitely affect the overall color balance.

Let's look at another situation where warm-colored walls warmed up the shadows. This shot (**2-10**) was done in open shade next to an orange wall. This color is great for skin tones, as it really helps to warm up the shadow side of the face. The subject stood only a few feet from the sunlit pavement. The large open area of sunlight on the street brightened her eyes by creating nice big catchlights (**2-11**).

Look at this next shot closely (**2-12**). This is open shade created by a yellow tent-like canopy. The color balance was corrected in Photoshop by using the hot dog wrapper as the white-balance target. But there are two distinct color temperatures in this shot: the light from the sunlight surrounding the canopy and the yellowish light from above passing through the canopy itself. Notice that the hair on the girl's right side is slightly yellowish, since the yellowish light coming from the canopy above is lighting it. The hair on her left side is more neutral in color, since it is shaded by her hat from the canopy and lit, instead, from the surrounding sunlight. Open shade is not always one color. It is a product of sunlight and the color within the shaded environment itself.

> Notice that the hair on the girl's right side is slightly yellowish . . .

A Short Primer: Color Temperature

The term "color temperature" refers to the Kelvin scale for measuring the color of light. The higher the color temperature number on the scale, the more bluish the light appears; and the lower the color temperature number, the more orange or warmer it appears. Some common light sources and their color temperature:

Light Source	Color Temperature
Candlelight	1800K
Sunrise/sunset	3000K
Midday sun on a clear day	5500K
Overcast sky	7000K
Household light bulbs (incandescent)	2400–3000K
Tungsten/Quartz photo hot lights	3200K
Fluorescent lights	4200–6000K
Open shade	9500K

Different Qualities of Light

Along with different color temperatures, open shade can show different qualities of light as well. Placing your subject in open shade in a city environment will render a different look than placing your subject in open

shade in the country. Shade is shade, isn't it? Not really. The light source can be larger or smaller depending on the surrounding environment. The previous photos were done in open shade in the city. Even though it was a bright sunny day, the area outside of the shade (the light source) was partially blocked by buildings, cars, signs, telephone poles, etc. In the country, the light can come from 180 degrees in front of your subject. The wide-open spaces create an entirely different type of open shade.

For this shot (**2-13**), the model was standing in the open shade of a doorway with a piece of black velvet hung behind her. The rectangular shape of the doorway can be seen in the catchlights in her eyes. This is the third version of open shade lighting: open-shade front lighting. The surrounding environment is a rural area with a big sky and open horizon, creating a very large light source. It's very similar to studio glamour lighting,

2-13. Open Shade Front Lighting. The subject stands in shade facing a large open area with big skies.

where one softbox is positioned slightly above the model and another is positioned slightly below. This type of soft, frontal lighting works great for portraits. It's possible to get studio lighting out on the farm. It's not just big-sky country, it's also big-light-source country.

It is also possible to make open shade into a more directional light source by shooting in another version of the tunnel of light (see chapter 1). For this image (**2-14**), the model stood in between the side of a building and a tall hedge. The camera position was just at the edge of a sunlit pavement area. Some sunlight spilled over the hedge and lit the back wall of the building, the top of her head, and her right cheek. The light on the front of her

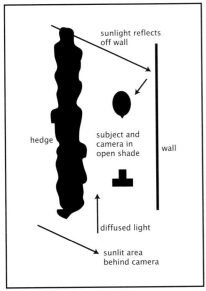

Diagram 3.

2-14. Open shade light can be given more contrast by having the subject move further away from the light source.

face and eyes, however, is from the sunlit pavement behind the camera. Since the model was standing further back in the open shade, the light on her face was more directional. The further you have your subject move back into the shade, the smaller the light source becomes. The smaller the light source becomes, the more contrast it will have. On the other hand, if your subject stands just out of the sunlight in open shade, then the light source will be very big and create soft, low-contrast light.

Sometimes you are limited with the amount of shade available. There might only be a small patch of shade to work with. Another problem with "small shade" is the background. You don't want to press your subjects up against a boring wall just because it's shaded. The best option is to shoot "through" the open shade to the sunlit background behind the subject. In this image (**2-15**), the group sat in a small shaded area that just barely covered them completely. There was a wall to camera right. I stood in the sun to take the shot and used a lens shade to block any potential flare. The washed-out sunlit area in the background creates an effective contrast to the dark clothes and hair of the family, adding dimension to the image. This point of view works much better than if the family had their backs to the

2-15. Shoot through the open shade to the sunlit area in the background in order to create dimension. Try to avoid positioning your subjects with their backs against walls.

2-16. Sunlight from the rear of the subject can be used as a hair light and edge light.

2-17. The hair-light effect from the sun is even more effective when coupled with a shaded background.

wall and the camera position had shifted 90 degrees to the left. The family and the wall would have both have been exposed evenly, but it would have been a safe and boring shot.

Another advantage a sunny day offers is that you can use the sunlight like a studio hair light or edge light. It's a great way to create depth in your portraits, as it helps to separate your subject from the background. The model in image **2-16** stood in open shade with a vertical column just to her right side. I positioned her so that the column shaded the front of her face from the sunlight coming from behind herm, but I also let some light catch the side of her face, hair, and even eyelashes—the edge-light effect.

Image **2-17** shows another hair-light effect from the sun. The afternoon sun came from behind the boy to frame the upper edge of his hair and shirt. The out-of-focus fence in the background created an effective background. Since it was in open shade, it remained dark and provided good contrast to the lighter subject. Also, remember that backlighting and open

shade work great for photographing kids, since the light remains consistent if they decide to move.

Image **2-18** is a slight variation on the last shot. Once again, the sun came from behind and acted as a hair light. But this time, the camera's built-in flash was used to fill in the front of the subjects' faces. The flash was set to –1.3 stops (1.3 stops below the metered level of the natural light) to act as a subtle fill light without overpowering the natural light. Under-powering the flash made the shot look more natural than if the flash had been set to +1.0 or +2.0. If the flash is set too high, the portrait will look definitely "flashed" and more artificial.

2-18. Using the on-camera flash at low power (–1.0 to –2.0) will create a subtle fill light on the subject's face and small catchlights in their eyes.

Sunny Day Projects

When shooting on a sunny day, remember to work with the elements. Sunlight creates strong shadows and rich color. Create a photo that emphasizes shadow and color.

1. Photograph your subject wearing bright colors. Let shadows fall across your subject or the background.
2. Photograph your own shadow as it falls on a colorful background.
3. Sunlight creates hard, graphic shapes. Place your subject in a setting with strong lines or shapes.

Open Shade Projects

1. Photograph your subject in an open shade area with warm-colored walls. Then try an area with cool-colored walls to see the difference in the shadow areas of your subject.
2. When working in open shade, try positioning your subject close to the sunlit area (but still in shade) and then try moving them further back into the shade to create different qualities of light. The further they move from the light, the more contrast will come from the light. Small light sources create harder light. Larger light sources create softer light.

> When working in open shade, try positioning your subject close to the sunlit area . . .

3. Place your subject in open shade but shoot through the shade to the sunlit area behind them. The sunlit background will create a distinctive contrast to your shaded subject. Use center-weighted metering to get the correct exposure on their face.
4. Position your subject at the back edge of open shade so that sunlight catches the back of their head, creating a hair-light or edge-light effect.
5. Use a fill flash set at −1.0 to −2.0 when photographing your subject in open shade to give them subtle fill and catchlights in their eyes.
6. Try an open-shade portrait in the wide-open spaces of the country. The big sky will create very soft light.

Backlighting and Flare

When we take a portrait, we want light to come from somewhere near the camera and illuminate our subject's face, right? Or if we are shooting a still life, we want the light to light up all the important details on the front of the subject. Right? Well, not always. In fact, as you progress with your lighting skills, you will notice that light that is actually behind your subject will give your subject a whole new feel. You may even use backlighting as a starting point for your shots. Backlighting creates depth and dimension. Your subject will stand out from the background because they will be lit by a different quality and direction of light. They are lit by light that is bouncing off something in front of them. Remember: bounced light is good light.

> You may even use backlighting as a starting point for your shots.

Creating Value Contrast

Here is a good example of backlighting (**3-1**). The late afternoon sun came from behind the model as she sat under an overhang on the riverfront. The overhang created an area of open shade for her face, but the back of her head was still lit by sunlight. The river and bridge in the background were in bright sun. Sunlight reflected off the nearby concrete to bounce light back onto her face. A nice contrast was created between her correctly exposed face and the overexposed river and bridge in the background.

Overexposure can be your best friend in a situation like this. It washes out the background enough to keep the visual interest on your model. This is what's known as value contrast. Value simply means how light or dark an area of your photo is on a relative scale of black to white. Value contrast

3-1 (facing page). With the subject's back to the sun and face in the shade, a good value contrast is created between the subject and background.

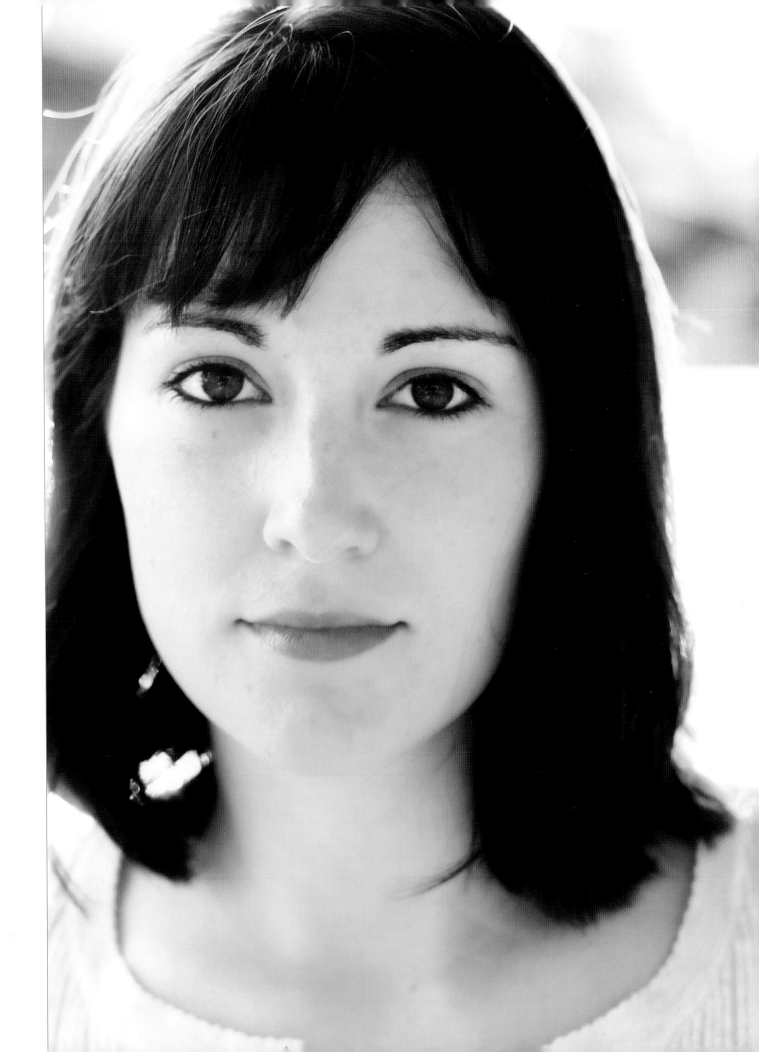

means creating contrast of lightness to darkness in your images. Your subject will really "pop" off the page (or your monitor) if they are set against a much lighter or darker value than themselves.

Image **3-2** had a similar setup to image **3-1**, except it was done on a rainy day. It was taken from a dark alcove looking out toward the model and the rainy city street behind him. The dark alcove reflected very little light back onto his face, making for an extreme lighting ratio from his face to the background.

When I first took this shot, I had wished I brought a silver reflector to bounce more light onto his face. But then I realized that there was an interesting contrast that was created between his dark face and the bright background (value contrast at work). It created some mystery and enhanced the dark mood of the rainy day. This is completely opposite from the shot above (3-1) of the woman at the waterfront, but it still works because of a good value contrast. Converting this to black and white also enhanced the feel.

So even though this is not great light on his face, it still makes for an interesting shot. I think it forces the viewer to look closely to try to understand the subject. Backlighting can hide your subject as well as reveal them.

A Silhouette Effect

Image **3-3** is similar to image **3-2**, but it was done in a more controlled environment. A parachute-like material (the 12x12-foot Artificial Silk made by Matthews) was hung from a living-room window to diffuse the afternoon sunlight. This effect could easily be done with a frosted white shower curtain, as well.

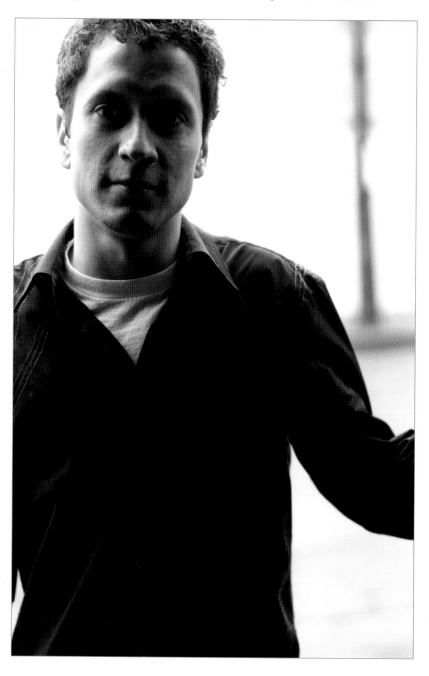

3-2. An extreme difference in lighting ratio between the dark face of the subject and the city street behind him creates a good value contrast.

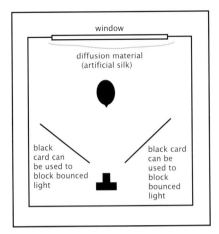

Diagram 4.

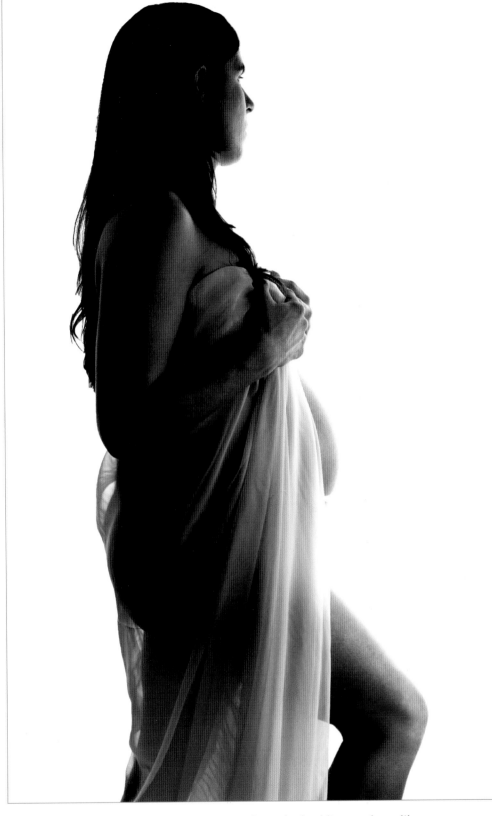

3-3. Window light from behind the subject was diffused through some parachute-like material.

Nearly all of the light for this shot came from the backlit parachute-like material. Very little light bounced onto the front side of the model from the interior of the room. This helped form the silhouette quality of the shot.

If you are in a similar situation but find that there is too much light bouncing back onto your subject from the front, you can position black cards to either side of the camera. This will help minimize any bounced light. It's as if you are making a big black box with one white translucent side for the model to stand in.

Avoiding Flare

When you are using backlighting, you have to be aware of lens flare. This occurs when light shines directly into the lens and creates strange geometric shapes and streaks of bright light. Those shapes are the actual shape of the lens diaphragm. Flare also lowers the contrast on the overall image. Flare can come from your backlighting light source (the sun, a bright sky) or an overexposed area in the background.

> When you are using backlighting, you have to be aware of lens flare.

Here's how to avoid flare. First, if possible, shoot from a shaded area. Second, use a lens shade. It will help to block light from hitting your lens directly. (I recommend getting lens shades for all of your lenses. Not only do they help minimize flare, they also protect your lens from damage in case the lens gets knocked or dropped.) Third, ask your model if they can see the sun reflected in your lens from their position. If they can, then you may get flare and will need to change your shooting position.

In the previous photo of the woman at the waterfront (**3-1**; page 39), I didn't have a problem with direct sunlight hitting my lens, because I shot from a shaded area. But I still could have had a flare issue because of the overexposed background. When the background is overexposed to the extent that it is in this shot, it could have the potential of becoming a huge light source itself—a big wall of white light.

To help prevent this, make sure that there is enough light bouncing onto your subject's face to keep the ratio of light between their face and the background within a four-stop range. You can test this by taking a very tight shot of your model's face—filling the frame with their face. Make a correct exposure of their face and make a note of it. Then, take a shot of the background correctly exposed. If there is more than a four-stop difference between these two shots, then you could potentially get flare.

Embracing Flare

Okay, now that you know how flare is formed, when it is likely to occur, and how to avoid it, let me just say one thing: *there is nothing wrong with having flare in your photographs.* Thank you. I just had to get that off my

chest. Flare can give your shots a dynamic element and a certain spontaneous or magical feel, in my opinion. So now that you've been given the green light on flare just be aware of one more thing: *flare is unpredictable, so you will need to do some test shots.* Using a digital camera, with its instant feedback, is an amazing time saver when working with flare.

The shots composited in image **3-4** show the unpredictability of flare. These eight frames were taken in quick sequence, as I changed my camera position to reveal more or less sun over the model's head. You can see the range from "not much flare" to "where did his head go?"

Don't be afraid to shoot a lot when you're working with flare until you find the right camera angle to get the kind of flare you like. Since backlighting and flare wash out the background, you can use this to your advantage to create graphic photos that emphasize shape and form. It's almost as if you are drawing your subject on white paper.

From this series of flare photos, I found the one I liked best and added a little Photoshop work to give it a more dramatic, graphic look (**3-5**; next page).

3-4. Many test shots are needed to get the best camera angle for showing just the right amount of flare.

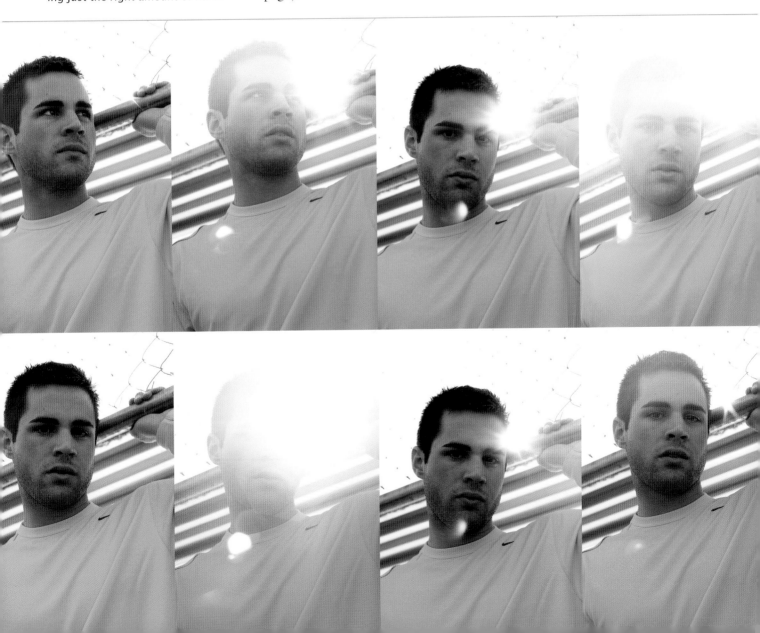

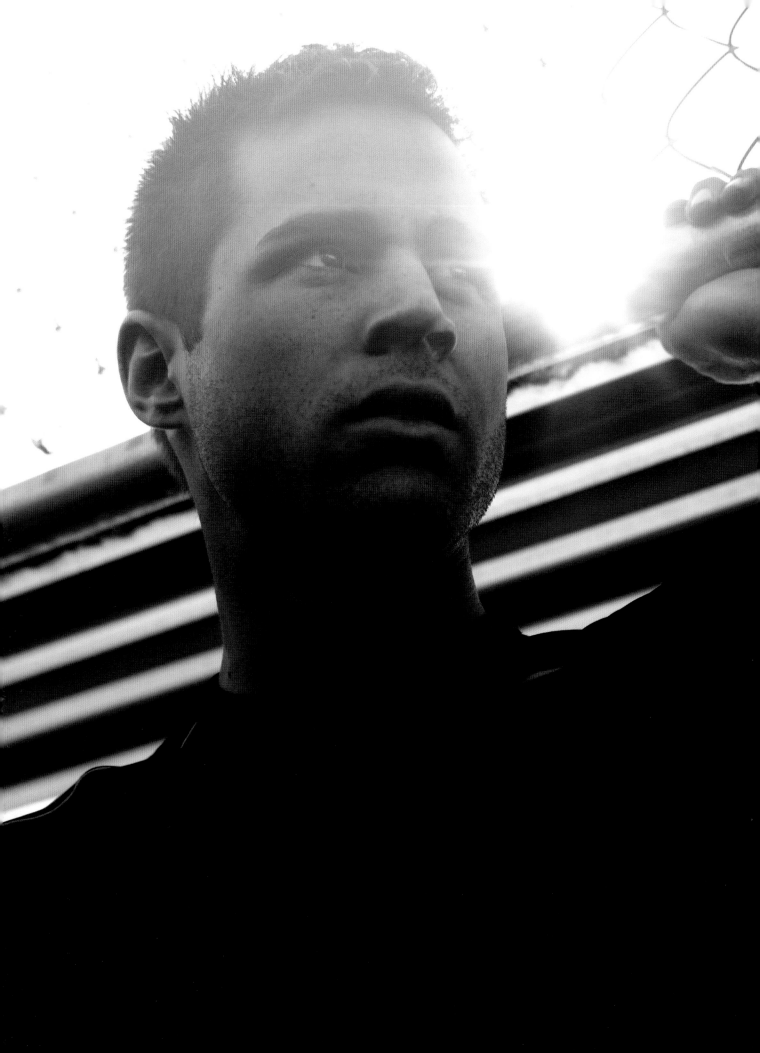

When working with strong backlighting or flare, the camera's light meter will not give you an accurate exposure if you shoot in a program, aperture, or shutter-priority mode. It will underexpose your subject when it sees all the sunlight—an attempt to "average out" the scene. It's best to take a center-weighted or spot reading of your subject's face with the sun completely hidden behind their head. Take note of that reading, set your camera to the manual mode, and dial in that reading. Then, you can be assured of an accurate exposure on your subject's face no matter how much you change your point of view and how much flare is revealed.

A safety note: Don't point your camera's lens at the sun for prolonged periods of time. It could potentially damage the camera's sensor (and your eyes). Personally, I've had no problem with my camera's sensor while shooting flare. I only point the camera at partial sunlight and for only a second at a time. Besides, when direct sunlight shoots straight into the lens, it does not make for a good flare effect, as you can see from a few of the shots above. Partial flare works best.

Lenses and Flare

Some lenses are better equipped at handling flare than others. They have higher quality glass in them. In fact, you may actually have to work a little harder with nicer lenses to get flare to occur. Your only option may be to use the brightest background you can find.

In this shot (**3-6**), the sun poured into the living room to light the back of the girl's head, creating some definite flare. I decided to use the on-camera flash to fill in the front of her face. At first, I photographed her with the sun coming from directly behind her, but it created too much flare. I settled on this camera position, where the sun was coming in from a less direct angle at the upper right. After a few test shots where I tried angling

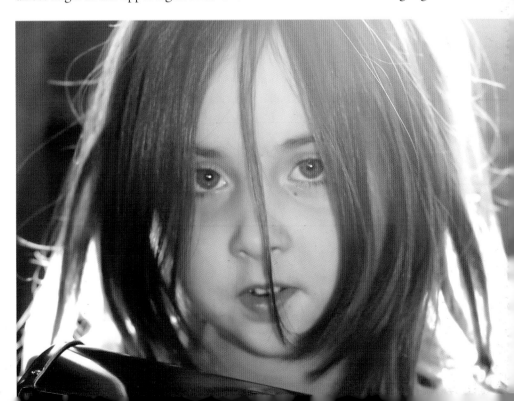

the camera differently to catch some of the sunlight, I finally got just the right amount of flare. This angle of light, combined with this lens, created the flare I wanted. Thank you digital camera and the instant feedback you provide!

The Human Flag

Professional photographers use flags to block unwanted light. A flag could be anything as big as a 3x3-foot black card mounted on a stand or as small as the photographer's own hand. A flag is simply anything that blocks light. Your model can be a flag, too.

Here is flare from a different light source—an overcast sky (**3-7**). The model and I were shooting under a pedestrian bridge that blocked nearly all of the light from the sky. A very dim light on the side of a building lit the model's face. Getting a correct exposure on her face meant that the overcast sky in the background was overexposed quite a bit.

For image **3-8**, I shot from a lower angle to get more flare potential from the overcast sky. After a few test shots, I found that framing the shot

3-7 (left). The subject stood under a pedestrian bridge. Getting a correct exposure on her face meant the background would overexpose—an opportunity for creative flare!

3-8 (facing page). The model acts as a flag to partially block some of the backlight, creating just the right amount of flare into the lens.

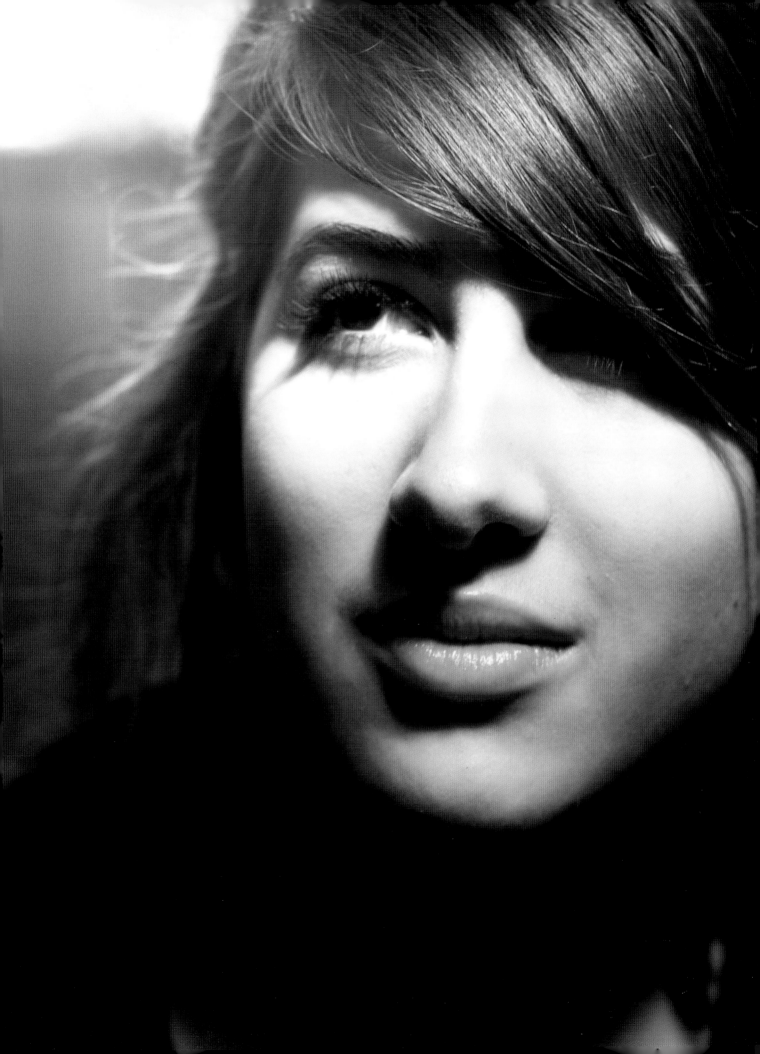

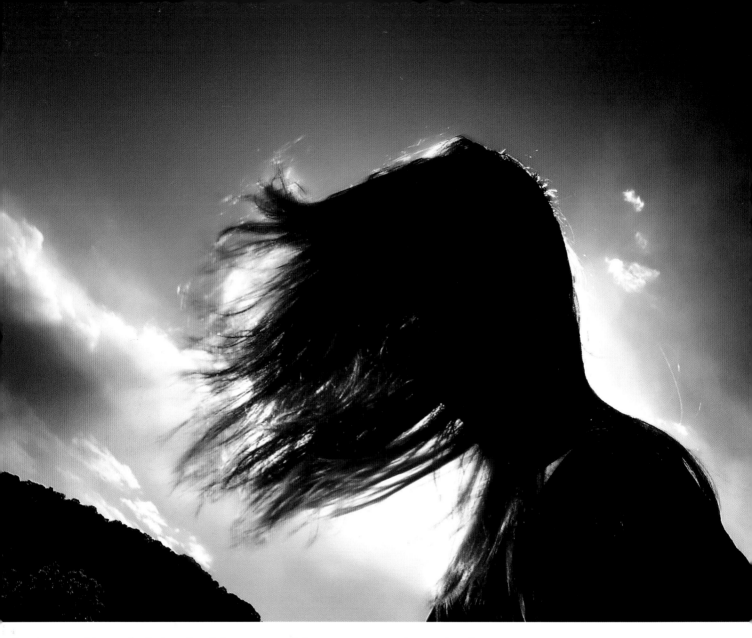

this way let in just the right amount of sky to create some interesting flare without overdoing it. Depending on how bright your backlight is, you can position your subject to block it partially to get the flare effect you want.

The Glow

One of the best aspects of working with light that is coming from behind your subject is that a glow will envelop your subject. When light passes through anything translucent, it lights up the person or object. In this shot (**3-9**), sunlight was directly behind the subject as the wind blew her hair forward. The on-camera flash was used to fill in the front side of her hair and body and also partially froze the movement of her blowing hair. The sunlight from behind shone through her hair to give it a golden glow. Hair is a good translucent subject for "the glow."

3-9. Late afternoon sun was directly behind the subject. Hair will light up and glow when backlit. A fill flash was also used to lighten the front of the subject.

If you are working with translucent or semi-translucent objects, use backlighting to really show them off and make them glow. In this shot (**3-10**), a little bit of sunlight shone through the clouds to backlight the model and the leaf. Notice the color of the leaves in the background. They are not being held up to the backlight, so their color is dull compared to the "hero" leaf. Use translucent objects as props for your portraits and backlight them!

3-10. Translucent objects are displayed best with backlighting.

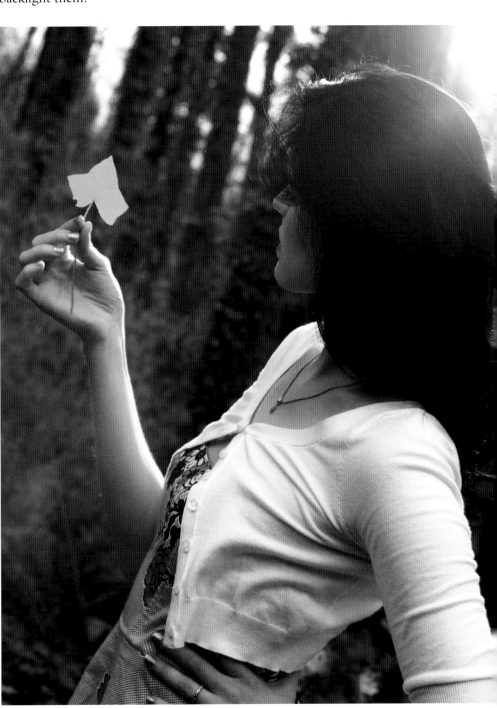

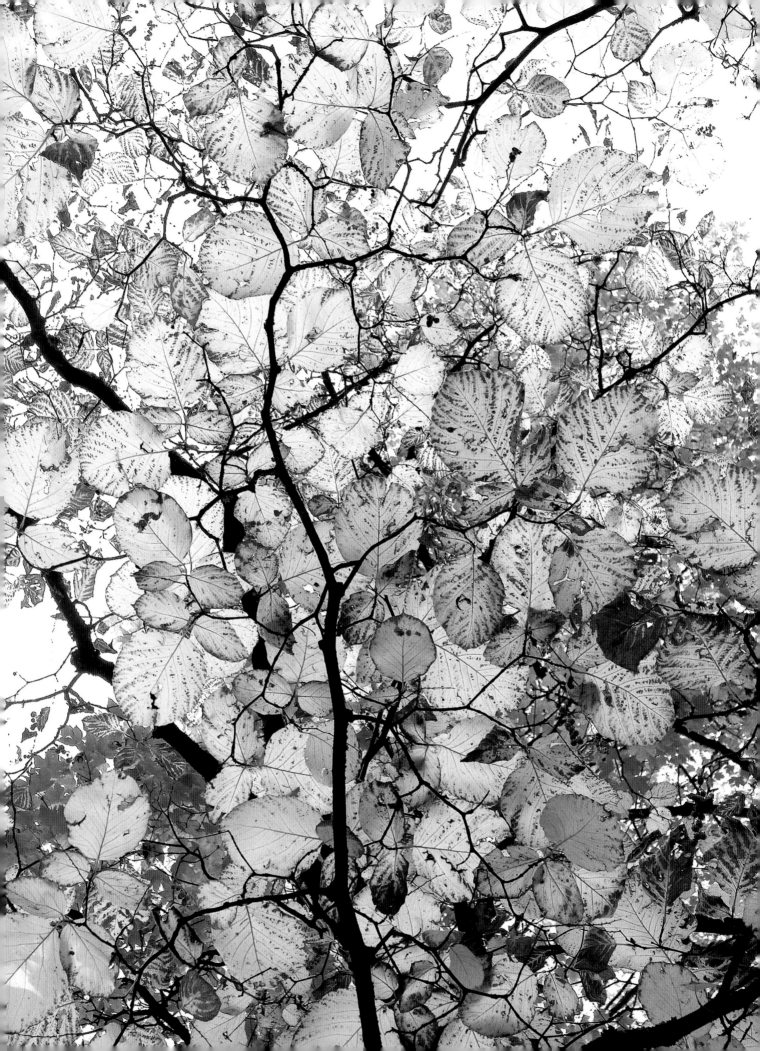

3-11 (facing page). An overcast sky can work well to backlight translucent subjects.

You don't need the sun to get "the glow." Image **3-11** was taken on an overcast day, looking up through the leaves toward the sky above. The sky in the background acted like a huge light table to cast its light through the leaves. Think of it as a drawing done on white paper. Use subjects with strong lines and shapes when photographing on a "light table" like this.

Projects

1. Use backlighting to create a strong value contrast between your subject and the background. Position your subject so that the background is receiving much more light than they are. Use center-weighted metering to get a correct exposure on your subject's face. Let the background wash out to white.

2. Use a similar setting to create a silhouette. But this time, place your subject in a darker area where little light hits them from the front. For example, shoot from the inside of your living room as your subject stands just inside the front door. Use the open daylight behind them as a background.

Use your subject as a flag to partially block the sun from hitting your lens.

3. Experiment with flare. Use the sun directly in your shot. Use your subject as a flag to partially block the sun from hitting your lens. Flare can come from any backlighting source. Look for other sources of flare—overcast sky, streetlights, or household lamps, for instance.

4. Find a translucent object and get it to glow with backlighting. Some ideas: Have a friend hold a beach ball over their head while it's backlit by the sun. Glass subjects always look great with backlighting. Any dusty or foggy location will have backlighting potential, as well.

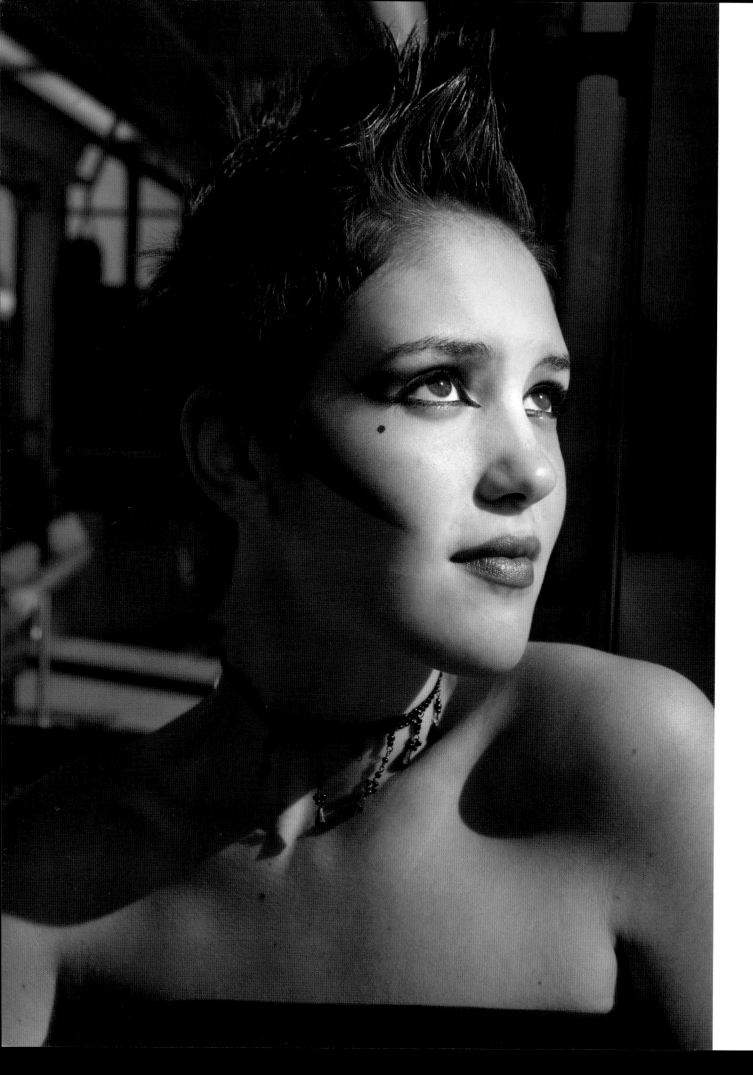

Window Light

P robably the first thing you think of when you think of doing a portrait in natural light is to use window light. I think you would be right. The great painters—Caravaggio, Vermeer, and Rembrandt—knew the beauty of window light. I suggest getting a book on art history to see how these masters used window light. Once again, it's all about control of the light, giving it direction and shape. The truth is that the beauty of window light comes not only from the actual window but also from the room inside the window.

Chiaroscuro

Image **4-1** may be a far stretch from the painting masters, but it does illustrate an effect the masters developed: chiaroscuro, the use of light and shadows to show shape and form. One of the best qualities of window light is that it can be made directional, helping to create this effect.

You may be asking yourself, "Isn't all light directional? Doesn't it come from somewhere?" Well, yes. Natural light comes from the sun and the sun is up above our heads. But it also bounces its light around our environment. In this shot, if the subject had been standing outside in the sunlight, there would have been much more light on the shadow side of her face and the top of her head. With the model sitting in a light rail car, however, the sunlight came strongly from the right. The interior of the light rail car acted as a flag to subtract the light coming from the top, back, and left side of her. When working with window light, our concerns are the quality of light from the window and how the room is blocking some of this light. This is what makes the light directional. This photo is another example of

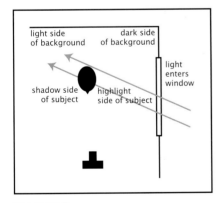

Diagram 5.

4-1 (facing page). Directional window light works well for the chiaroscuro effect.

subtractive lighting. The strong contrast creates the chiaroscuro effect, which shows the shape of her face and big hair.

Chiaroscuro creates strong contrast on your subject, but it also produces strong contrast between your subject and the background. In image **4-1** (page 52) the highlight side of the model (her left side) is against a darker background, while the shadow side (her right side) is against a lighter background. This concept of light against dark and dark against light helps to frame your subject and keeps the viewer's eye engaged. The directional quality of window light works wonderfully for this concept. It can project across an area to lighten the background behind the shadow side of your subject while avoiding the background behind their highlight side.

Same Reflector, Different Looks

These two photos (**4-2**, **4-3**) were taken at the same location. In image **4-2**, window light from an overcast day poured through a sliding glass door to the right of the camera. The room was a fairly dark living room that did not bounce too much light back onto the shadow side of the subject's face. I decided to create a

4-2 (above). Window light from the right of the camera was filled in with a silver reflector on the left side.

4-3 (facing page). The subject faced the silver reflector with her back to the window. The silver reflector is a flatter light source now and the window acted as a hair light.

more even light—something less dramatic than the punk girl on page 52 (**4-1**), though (some subjects need more drama, some less!). To do this, a silver 4x4-foot reflector was placed on the opposite side of the subject to bounce light back onto the shadow side of the face. It's easy to control how much fill you are getting from the reflector by moving it closer or further away from the subject. In this shot, it was very close to him (almost touching his right shoulder) to create a subtle contrast from the light side of his face to the shadow side.

In the photo of the young woman (**4-3**), the camera, window, and reflector were all in the same position as in image **4-2**. The only thing dif-

ferent was the position of the subject. She was posed facing the silver re-flector and has her back to the window. Having her face the reflector directed the light straight at her face, producing a softer look. A lighter exposure was made (a half stop lighter), since she was facing the shadow side of the scene. This made the window light slightly overexposed on her hair and shoulder, giving a soft hair-light effect.

4-4 (facing page). A large window was selectively flagged to keep the lighting emphasis on the subject's face.

Focusing Window Light

One of the best aspects of shooting by window light is that, with slight modifications, the size of the light source can be changed to create a more focused light.

In this shot (**4-4**), the subject was lit from camera left by a 6-foot high window. Usually it's a good thing to have a tall window, because it throws soft light out into a big area. In this instance, however, I wanted to focus the light and keep the emphasis on the subject's face. By placing pieces of black foam-core board near the subject, I was able to flag some of the light from the top of the subject's head, his hand, and the back of the table. Using four pieces of foam core that were clamped together with a cutout in the middle, I created, in essence, a miniature window. I also used black foam core to block some of the window light from hitting the background. It's nice to have a large window to work with, since it can light a large area. But that same large window can be reduced in size by blocking some it with anything opaque. Then you can highlight selected areas and shade less important ones.

> Using four pieces of foam core, I created, in essence, a miniature window.

Lighting Heaven

Window light can be shaped and directed by shooting in a dark room. Shooting in a bright room can have the opposite effect by completely flattening out the light, producing a soft and flattering look. Keep your eyes open for rooms with white walls and white or bright floors, and windows on adjacent corners—hopefully high windows. If you find a room like this, you've in Lighting Heaven (you will know by the glow of white light and the friendly welcoming committee).

This is how those high-priced daylight studios are designed. I'm not talking about our budget daylight studio discussed in this book. These are the ones in New York or Los Angeles that are built in lofts and are rented by the day (do an Internet search for "daylight studio"). These spaces work so well because their interiors act as one big reflector to bounce window light back onto the subject.

Image **4-5** was done in a library that, luckily, had all of the prerequisites for Lighting Heaven: high windows on adjacent corners and a light-colored room. Sunlight came through the back window to light the model's right shoulder and the top of her head. It also lit up the entire room, creating a nice soft light that bounced onto the front of her face.

Big Windows

Big windows can light a big area. In image **4-6**, the subject was lit evenly from head to toe in another found Lighting Heaven location. There were 8-foot tall windows to camera left and the area surrounding her was bright, providing plenty of fill light. Indirect daylight poured in through the tall windows.

An area like this is great for full-length shots of individuals or for groups of people—big, soft light, in a white space. It also creates an interesting value contrast to a darker subject. Since the whole "set" is flooded with light, you can make a compelling portrait if your subject has darker clothes or skin than the bright background. Another possibility is to have your sub-

4-5 (below). Tall windows on adjacent sides, a brightly colored room, and sunlight equals Lighting Heaven.

4-6 (facing page). Tall windows from camera left lit a bright space to create soft, even light that covers a large area, ideal for full-length portraits or group shots.

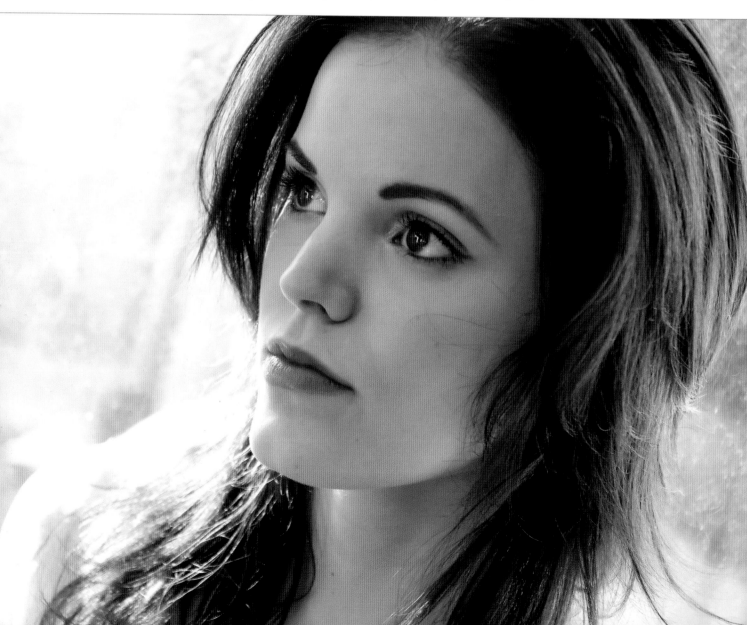

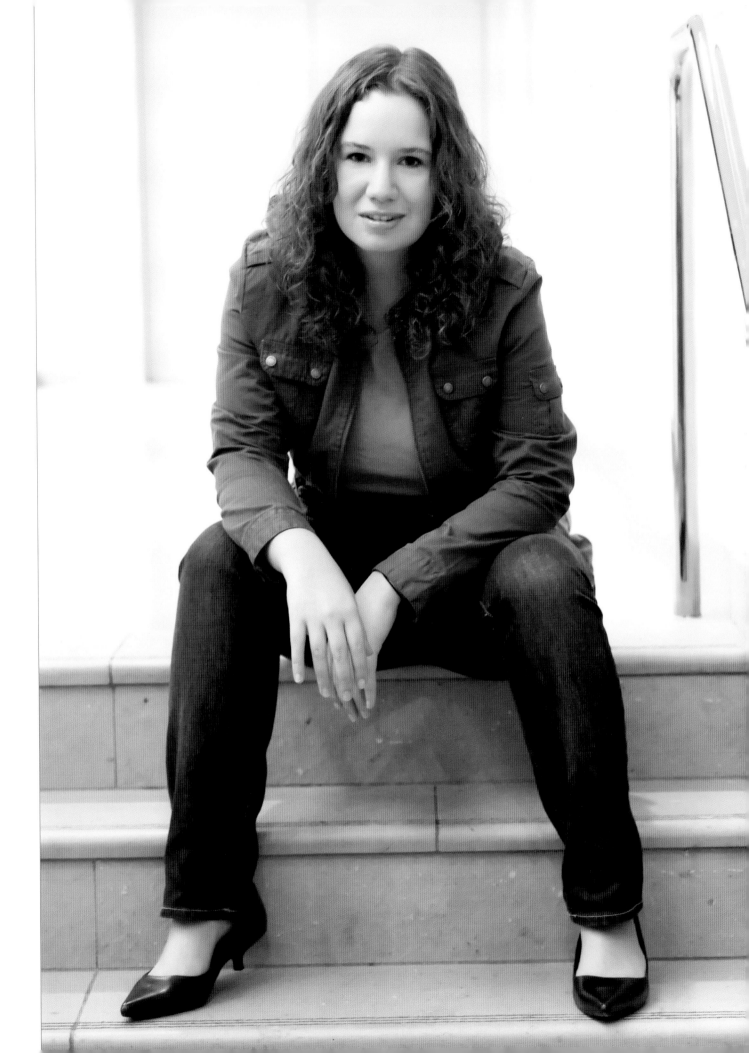

ject wear white or light-colored clothes against a bright area, such as this. Then their skin would stand out in contrast as the darkest tone in the shot.

Small Windows and Camera Shake

Small windows have their advantages, too. In image **4-7**, a small window to the right of the camera lit the subject with soft diffused light from an overcast sky. The room was dark and bounced very little fill light onto the shadow side of her face. Since this was a small window, it projected light into a small area—basically just the area of her face and hand.

Enter the inverse square law, a simple calculation used to measure the falloff of light. Here's how it works: Since the subject sat right next to the window, the light fell off quickly from the highlight side of her face to the shadow side. The window was just out of camera view to the right and about one foot from the model's left shoulder. The shadow side of her face, though, was about two feet from the window. This means that the shadow side of her face received one-fourth the amount of light (the inverse of two squared) that her shoulder did. In terms of f-stops, the shadow side of her face is two stops darker than her shoulder.

To simplify, the closer your subject is to the light source, the quicker the light will dissipate over distance. This type of quick light falloff can be used to create drama.

There is a potential problem when shooting with window light, though: not enough light. I had that problem in this shot (4-7). The combination of the small window, dark room, and the overcast daylight made it necessary to use a slow shutter speed. When using slow shutter speeds, it is difficult to handhold the camera without camera shake occurring. You may face this when shooting with window light, but don't let a low-light situation stop you from working with some beautiful window light. The general rule for avoiding camera shake is to choose a shutter speed that is at least as fast as the focal length of your lens. For example, if you were shooting with a 28mm lens, you would need a shutter speed of $1/30$ second or faster. If you were shooting with a 200mm lens, a safe choice would be $1/250$ second or faster. Nikon makes lenses with built-in Vibration Reduction. Canon has its own version called Image Stabilization. Other lens manufacturers have their versions, too. This technology allows you to shoot at slower shutter speeds without getting camera shake. Using a tripod and shutter release is another way to avoid camera shake.

If you don't have a vibration-reduction lens or a tripod, you can minimize camera shake with proper handholding technique. When holding your camera, keep your elbows tucked against your body, not flaring out to the

There is a potential problem when shooting with window light: not enough light.

4-7. The subject sat close to a small window, which created rapid light fall off from right to left.

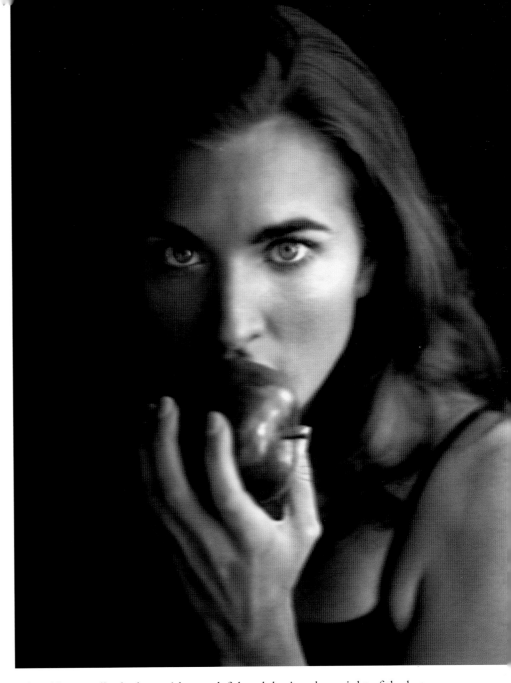

sides. Also, cradle the lens with your left hand, letting the weight of the lens settle onto your hand. Keep one finger on the shutter release at all times. Don't punch the shutter release with your finger when you make the exposure. Gently roll your finger across it. It's also helpful to brace yourself against a nearby support. Lean against a wall or tree, if possible. And, lastly, breathe correctly. Take a deep breath in, let it out half way, and then fire.

These are the rules regarding camera shake—but rules are made to be broken, right? Since you now know how to avoid camera shake, I invite you to create some images with camera shake. When I took this shot (**4-7**), I knew I was pushing my limit for handholding the camera. To get a correct exposure, I had to use a $\frac{1}{15}$ second shutter speed while shooting with

a 50mm lens. This produced a camera shake that created some dynamic tension in the image without going too shaky. Another interesting aspect of camera shake is that it will seem to blur middle tones more than bright

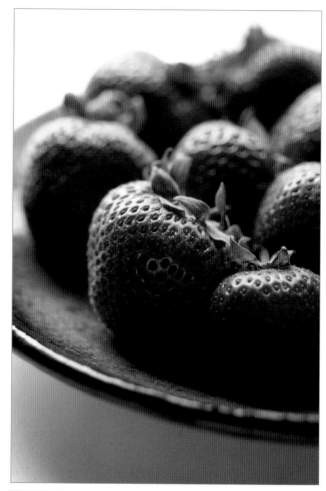

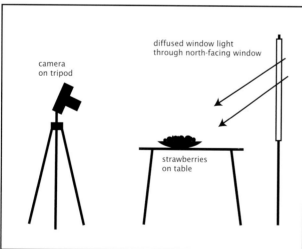

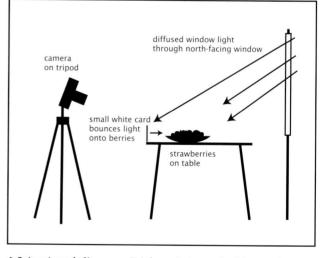

4-8 (top) and diagram 6 (above). Indirect light from a north-facing window was used to light the strawberries.

4-9 (top) and diagram 7 (above). A small white card was added to bounce light onto the front of the strawberries.

white tones or dark tones. There is not enough information in whites or blacks to create any blur. That means the whites of your subject's eyes will seem to have less blur than the rest of their face, which can create an interesting effect.

Whether you want camera shake or not in your shot, be aware of when it is most likely to occur. If you are going for creative camera shake, do plenty of test shots to determine the best shutter speed to shoot at. Also use the zoom function on the LCD monitor of your digital camera. You will need to zoom in close on your image to see the effects of camera shake, since it may not be visible when you are viewing the full frame of the image.

Window Light and Food Photography

Food is best photographed under soft lighting that comes from above and slightly behind the subject—a perfect situation for window light. This series shows the basic setup for food photography. In the first shot (**4-8**), soft light from a north-facing window lit the strawberries from about a 45-degree angle from behind.

For the second shot (**4-9**), a small white card was added to bounce light onto the shadow area at the front of the strawberries.

The third shot (**4-10**) shows the effect of a black card placed above the berries to subtract some of the highlights on top of the strawberries and effectively reduce the contrast ratio between highlight and shadow.

Projects

1. Use window light from the side of your subject to create the chiaroscuro effect of the painting masters. Make sure the highlight side of your subject is against a darker background, while their shadow side is against a lighter background. This will work better in a darker room.

2. In a similar set-up, add a reflector on your subject's shadow side. Have your subject sit in three different positions: facing the window, facing the camera, and then facing the reflector. You will have to

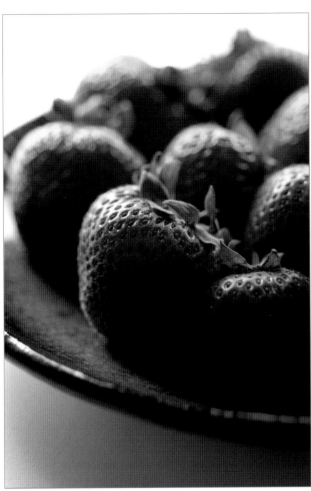

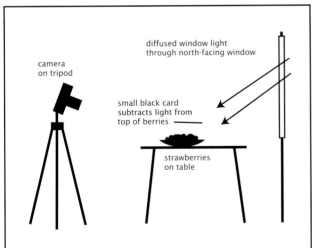

4-10 (top) and diagram 8 (above). A black card placed above the strawberries reduced the highlights.

make a lighter exposure for the last position. Move the reflector closer or further away to affect the lighting ratio from side to side on your subject.

3. Use opaque material to block some window light from areas of your subject. For example, use a black card to block light from hitting the lower half of their body, creating a soft spotlight effect on their head and shoulders. Or, conversely, use a black card to keep light off their head in order to spotlight something they may be holding in their hands—a book, some flowers, a baby, etc.

4. Go find a Lighting Heaven location. This is a room with white walls, a light-colored floor and windows on at least two sides. There are many lighting possibilities here. Your subject will be enveloped in light. If sunlight enters the room, you can combine its higher contrast with the softer bounced light from the room. Overcast or shaded window light will create entirely soft light. Either way, move your subject close to one window or the other to create subtle differences in lighting ratios on either side of their face. Or have them stand between windows to create two sidelights on their face. Or have them stand with their back to a window to create a backlighting effect. Keep value contrast in mind, by making sure your subject's face, hair, or clothes are the darkest tone in the shot.

Use small windows to create drama with quick light falloff.

5. Use large windows to your advantage. Since they light a big area, use them for full-length shots of people, group shots, or for any subject that needs room to move (animals, kids, dancers, athletes, etc.).

6. Use small windows to create drama with quick light falloff (again, remember the inverse square law). Position your subject very close to a small window to see how fast the shadow side of their face goes dark.

7. Don't avoid low-light situations. Learn the rules to avoid camera shake or use a subtle amount of camera shake to create tension in your images.

8. Photograph a plate of food next to a window. Soft, diffused light works best, so use a northern-facing window or diffusion material on the window if you are getting direct sunlight. Set up your scene so that the window is at the rear of the shot (it can be either seen or hidden in the frame). Let the soft light wash over the food from above and slightly behind the subject. Use reflectors to fill in shadows at the front of the food or black cards to knock down highlights on top of the food.

The Daylight Studio

*T*o create beautiful outdoor portraits with a professional studio look, you can make a simple daylight studio. It's simple to do yourself and is much cheaper than building an indoor studio. You won't even have to hassle with construction permits or zoning restrictions. And you can take it with you.

A Secret Revealed

I am about to reveal a secret that photographers have been holding onto. Please destroy this book after you read it so that the information will not leak out to the general public. Here is all you need to get a simple daylight studio look: a piece of white foam-core board. That's it. You can buy these inexpensive secrets at your local art supply store. I recommend a 2x3-foot piece. Get a few.

The Correct Ratio

Image **5-1** (next page) was done on a hazy day. The model sat in open shade. A piece of white foam core was positioned behind her in hazy sunlight. I acquired a good exposure on the model's face by moving in close, filling the frame with her face, then noting what the camera's meter said. You can also use center-weighted or spot metering to obtain the correct exposure for the subject's face. I then moved further back to compose the shot, set my camera to manual mode, and shot at the exposure I had noted. Don't shoot in program or auto mode when working with a white background, such as this. Your camera will read all of

> I am about to reveal a secret that photographers have been holding onto . . .

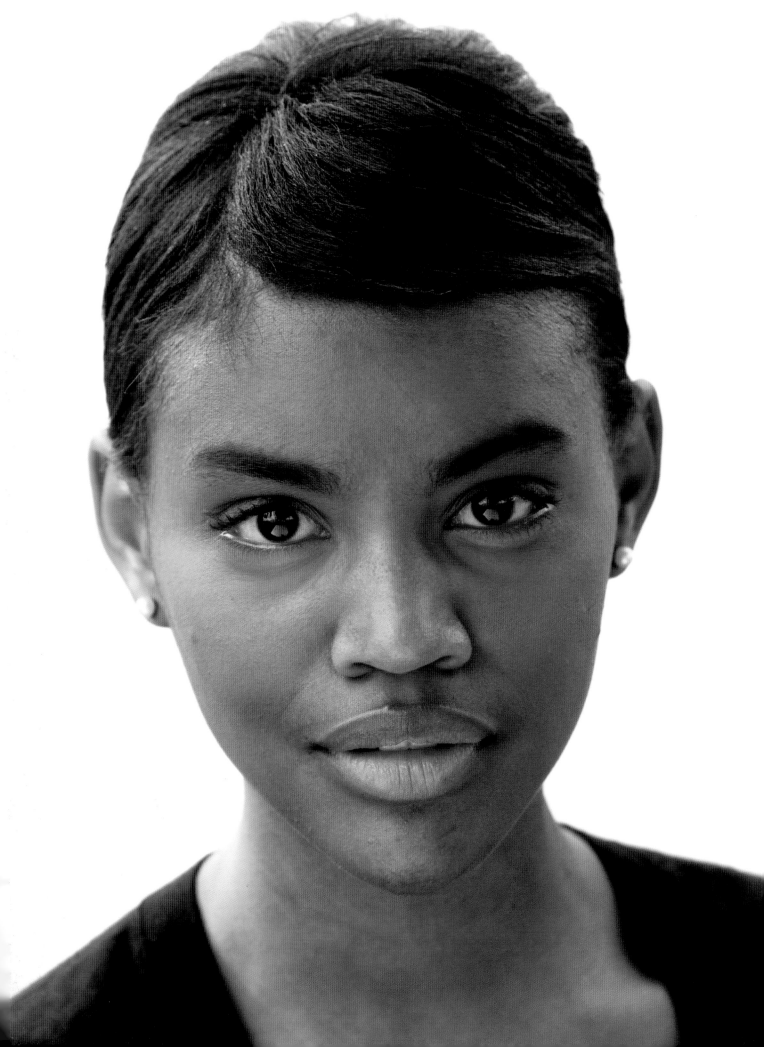

5-1 (facing page). The model sat in open shade. The white foam core behind her was placed outside of the shade in hazy sunlight.

the bright white background and close the lens down, resulting in under-exposure on your subject.

The foam core reflected the hazy sunlight and went pure white because it was overexposed in relation to the model. If I had placed the foam core in the open shade with the model, it would not have gone pure white but would have been gray instead, since it would be receiving the same amount of light as the model. Thinking in terms of f-stops, the foam core was receiving two stops more light than the model.

When you create the daylight studio, it's all about controlling the ratio of light between your subject and the background. The hazy sunlight this day worked perfectly. If the foam core was in very bright sunlight, it might have been too bright in relation to the model and would have flared into

5-2. The setup for the daylight studio on a sunny day. You can see diffusion material above the subject, foam core as a background, and a second piece of foam core on the ground to bounce light from below.

the lens. If this happens, you can control the brightness of the foam core by angling it away from the sun slightly.

I must confess that, on this shot, I also used a second piece of foam core, which doubled the budget from three dollars to six dollars. It was placed on the ground in front of the model to bounce light onto her face from below and to brighten her eyes. You can see it reflected in the bottom half of her eyes. Shhh! Foam core is the secret—don't tell!

The model and I had so much fun with the daylight studio that we set it up again on another day. This time it was a bright, sunny day with clear blue skies. Image **5-2** (previous page) is a shot of this setup.

For this setup, I clamped a piece of white foam core to a stand behind her. Then I placed a 3x3-foot piece of white translucent material above her. The one I used is from Calumet and stretches nicely over a collapsible PVC-type of tubing. You can easily make your own version, though. Try stapling a frosted white shower curtain to some lightweight boards. It will provide soft, even lighting that effectively turns sunlight into a 3x3-foot softbox above the subject (**5-3**).

In this setup, one problem was that the soft light was coming from directly above the subject. This is the same problem encountered on an overcast day. Anytime a light source comes from directly overhead, it gives your subject bags under their eyes. Fortunately, there was a lot of light from the surrounding area bouncing onto the subject's face to help mitigate the problem. But the best solution is to add another piece of white foam core on the ground in front of the subject to fill in the light on their eyes (**5-4**).

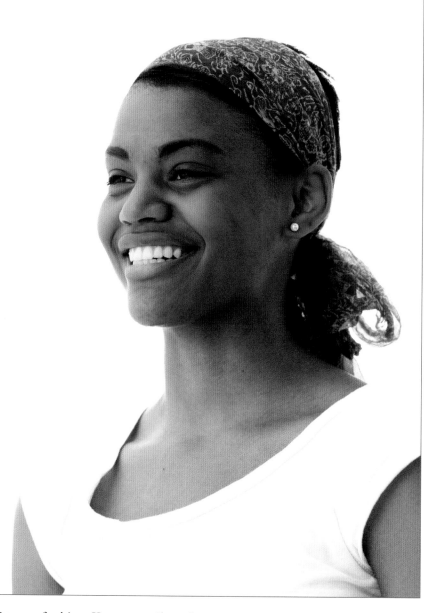

5-3 (above). The diffusion material from above and surrounding light provide a soft light.

5-4 (facing page). Adding a piece of white foam core from below helps to fill in the light on the model's face and produces good catchlights.

5-5. When the white background is receiving significantly more light than the subject, it will wrap around the sides of the subject. Too much will produce flare.

Extreme Ratio

This shot (**5-5**) is a bit different, because the ratio between the model and the background is much higher.

To create this image, the model sat on a porch in the open shade. This open shade area was much darker than the previous shots. White foam core was placed behind her in direct sun and bounced a lot of afternoon sunlight back toward the lens. The foam core actually received *four stops* more light

than the model—quite a big difference! You can see how the white background wrapped around her shoulder and almost began to flare into the lens. The outline of her body was blasted out by all of the white light from the rear—I wouldn't want the white to be any brighter than this. This is an effective look as long as her face doesn't start to get washed out, too. I don't mind that her edges are washed out. It gives her a glowy (is that a word?), angelic look. A silver reflector (**5-6**) was added in front of the model to bounce light into her eyes and to reduce the lighting ratio to the background somewhat. The reverse view shows the setup, especially how dark the porch area was.

You might be wondering about the size of the foam core. "Isn't it too small?" you might ask. I shot from near the doorway and used a telephoto lens, which helped compress the distance between the model and the background. The white foam core was just big enough, with this lens, to cover her head and shoulders. If I were doing a three-quarter length shot of her, I would need a bigger piece of foam core, given that it would have to stay in the same location in the sunlight.

5-6. The reverse view of the setup. A silver reflector and a small piece of foam core were all that was needed.

Absolute Black

Since you're going to the art-supply store to buy white foam core, you might as well stop by the fabric store and pick up some black velvet or velveteen. It's just as easy to create a pure black background as it is to create a pure white background. I find that black velvet works great for this, because it hardly reflects any light. You can try black construction paper, but it will be harder to get it absolutely black.

Remember that, when using the white foam core, it is placed it in a brighter area than the subject to assure that it goes pure white. You will need to do the opposite with the black velvet. Place it in an area that is darker than your subject. Image **5-7** is a shot of the setup for the black background.

I used the same translucent white diffusion material overhead again. The black velvet was draped over a stand in the open shade behind the model. Since it was in the shade, it was about two stops darker than the model under the translucent white, assuring that it would go absolutely black. I used the same metering technique as before (I metered tightly at her face

5-7. To get a black background, use black velvet positioned in shade behind your subject.

5-8. The result is soft light on the subject and a solid black background.

5-9. For a variation, the subject stood just inside the open shade. No diffusion material was used. The black background was placed to the far end of the open shade.

for my correct exposure, then set my camera to the manual mode at that exposure). Do not shoot in program mode with the black background; the camera will attempt to "average" the scene and, as a result, overexpose your subject.

With this setup, the result is soft lighting from above with some fill from below bounced off the sunlit pavement in front of her (**5-8**).

Image **5-9** shows a variation on this setup. The translucent white material was removed and the model stood at the front edge of the open shade. The black velvet was moved to the far backside of the open shade, close to the back fence but still in the shade. Since an even more shaded area surrounded the black velvet now, it received significantly less light than the model and went pure black.

5-10 (right). This is the setup for a black background with sunlight coming from slightly behind the subject.

5-11 (facing page). The black background metered three stops darker than the light on the subject's face, assuring it would go absolutely black.

Image **5-10** shows a similar setup. I cut a piece of black velvet to fit inside a Calumet panel to act as a background. Alternately, you could tape black velvet to a flat board. Either of these methods helps to keep the velvet fairly flat. (Wrinkles in the material should be avoided because they tend to reflect light more.) I placed the background in the shade and had the model stand in the sunlight. The sun lit her from above and slightly behind, providing a natural hair light. For this shot, I used an incident light meter to find the correct exposure. Pointing the meter to the camera position, I metered from the top of her forehead to catch some of the sunlight at the top of her head as well as the shaded area on the front of her face. This method assured that I didn't let her hair overexpose to white.

Then, I metered at the black background with the meter pointing to the camera position. It was three stops less than the exposure on her forehead. Success! If you can underexpose a black velvet background by at least two stops, then you know it will go absolutely black (**5-11**).

Understanding The Camera's Histogram

The histogram is a bar chart that shows the levels of blacks, whites, and middle tones in an image. If there are a lot of shadows or dark areas in an image, then the histogram will show a heavy concentration of bars on the left side of the chart. If the bars seem to continue off the left side of the chart, then there is absolute black in the image. Conversely, if there are a lot of bright areas in an image, then the histogram will show a heavy concentration of bars on the right side of the chart. And if the bars continue off the right side, then there is absolute white in the image.

> The histogram shows the levels of blacks, whites, and middle tones in an image.

Diagram 8 shows the Photoshop Levels dialog box. This is a histogram similar to that on the back of your camera. For image **5-9** (page 73), the chart shows bars continuing off the left side. This indicates that the black velvet background is absolutely black. The chart also shows a heavy concentration on the right side. This is the white shirt that the model is wearing. The bars do not continue off the right side, though, indicating that the shirt is not absolutely white but retains a small amount of detail.

Use your camera's histogram to see if you have absolute black or white in your image. There will be instances, like working with the daylight studio, where you will want absolute black or white. But there will be other shooting situations where you will not want any important information in your image going absolutely black or white.

Diagram 8.

Do not rely on what the camera's LCD monitor is showing you regarding exposure when you play back your images. Images may look fine on the monitor but there could be important information that is being lost. Refer to the histogram instead. It is a better indicator of the tonal range in your image.

Keep in Mind

1. The daylight studio look is best achieved when you can control the lighting ratio between your subject and the background. If you are using a white background, make sure it is receiving more light than your subject. If you are using a black background, make sure it is receiving less light than your subject. Work with open shade to achieve the best ratio.

2. Use a telephoto lens to compress the distance from your subject to background. This way you won't need a huge piece of foam core or black velvet to fill the frame behind your subject.

3. Don't shoot in a program or auto mode when using a white or black background. The in-camera meter will be fooled by the background and either underexpose or overexpose your subject. Take a center-weighted or spot reading from your subject's face. Note the exposure and then set your camera to manual mode at this exposure. Then you can walk back and compose the shot as you like and be assured that there will be a good exposure on the subject's face.

Use a telephoto lens to compress the distance from your subject to background.

4. Use an incident light meter to measure the difference in exposure between your subject and the background. For a pure white background, make sure the background is one to two stops brighter than the subject. For a pure black background, make sure the background is two to three stops darker than the subject.

5. You can also check your camera's histogram to see if your exposure has pure whites or blacks. If the histogram graph shows information continuing off the right side, then you have pure white in the shot. If the graph shows information continuing off the left side, then you have pure black in the shot.

Natural Reflectors

So what exactly is a "natural reflector?" It's any existing surface that's reflecting light. It could be the side of a building, sand at the beach, a car windshield, or the pages of the book you're reading right now. The reason I call them "natural reflectors" is that they exist around us all of the time. Another term for what these reflectors provide is bounced light. The biggest advantage of working with natural reflectors is that you don't have to carry around extra reflectors with your gear and, most importantly, they help to train our eyes to look for them. Reflected light is beautiful. It can have a soft or hard quality, depending on the surface quality of the object that is doing the reflecting. So head out there and find some natural reflectors.

> Another term for what these reflectors provide is bounced light.

Indoor Natural Reflectors

Image **6-1** was taken in a library with the available overhead fluorescent lights. It was shot at ISO 1600 in order to handhold the camera. I was able to shoot a $\frac{1}{100}$-second exposure at f/4.5. Believe it or not, this type of office lighting is actually good for portraits. It is soft, but it also has some directional quality (you can see the light fixtures on the ceiling in the background of this shot). The lights are like studio softboxes placed on the ceiling at six-foot intervals. The only problem is that they are coming from directly above the subject's head, so if you aren't careful you could get the "sunken eye" look on your subjects—like the light on an overcast day.

One solution is to use a natural reflector to bounce light back up to the subject's face. A book makes for an excellent natural reflector. (Now if we

could only find a book around this place!) Notice the catchlight in her eyes from the pages of the open book. This shot is similar to the overcast day series shown earlier, where the model turned away from the overcast sky and looked down toward a silver reflector.

Since office lighting is very similar to overcast daylight, another solution to getting a good portrait would be to flag the light directly above your subject to make it more directional from the front (see chapter 1 for more on this).

6-1. The pages of a book serve as a natural reflector to bounce light up into the subject's eyes.

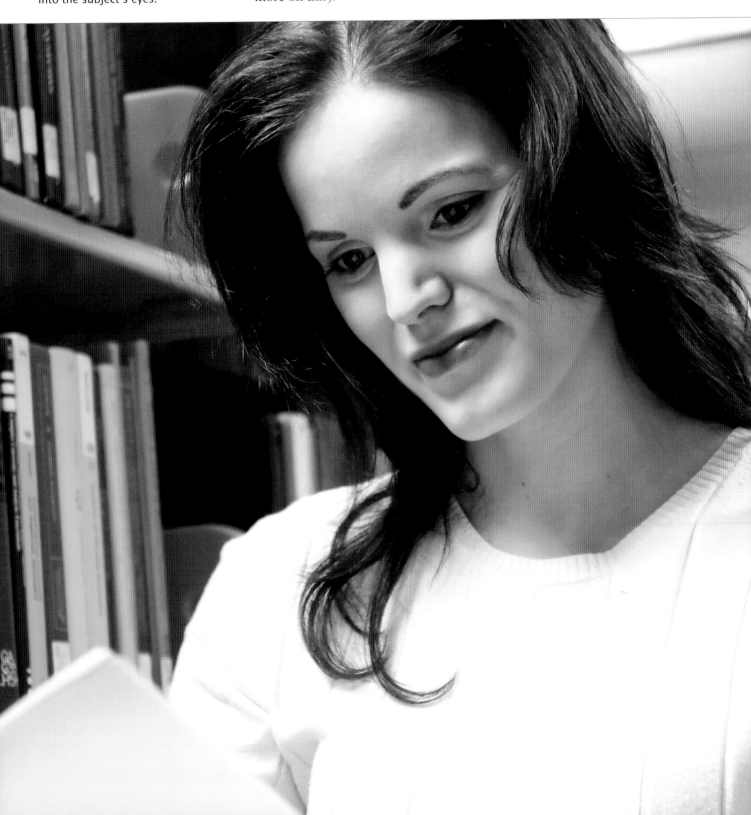

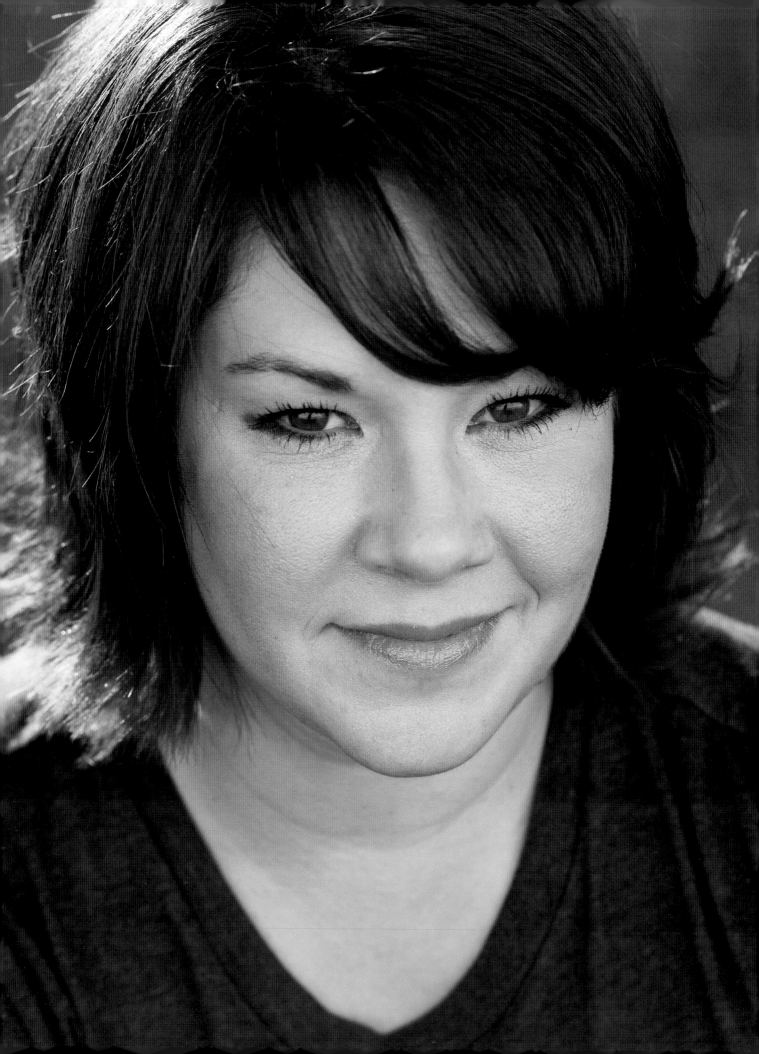

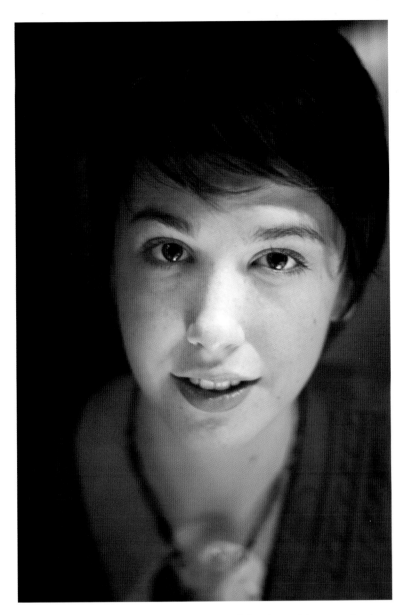

There are natural reflectors everywhere. Image **6-2** was done in a café that had metallic gold countertops. The lights were halogen spotlights that shone down on each table. We tried some shots where the subject looked up toward the halogens, but they were very high contrast and created deep shadows on her face. When she angled her face down to the shiny table the effect was better. Bounced light is softer than direct light. The halogen light that bounced off the tables made a nice fill light from below. The catchlight in her eyes is from the metallic countertop.

In the movie industry they use what are called "shiny boards" to bounce light into a scene. These are usually 4x4-foot wooden boards covered in shiny metallic material. They come as part of the whole grip package with the truck full of gear and a grip dude or two. Essentially, we found the same thing at this café—and for free. So, get shooting, Spielberg!

The Right Time of Day

A great time to find natural reflectors is in the afternoon when the sun is lower in the sky and casting longer shadows. In image

6-2 (above). Overhead halogen spotlights lit the subject from above. A metallic table bounced light from below.

6-3 (facing page). Afternoon sunlight, bounced off the large white wall of a building, created soft flattering light and large catchlights in the subject's eyes.

6-3, the subject sat in the grass in open shade. The afternoon sun came from behind her and bounced off the side of a building (behind the camera position) with a large white wall. More bounced light! The wall became a huge, soft light source. Notice the large catchlights in her eyes—obviously from a big source.

The light was nearly too bright for her eyes, as she is almost starting to squint. I feel this type of mild squinting is fine, though. It gives your subject some intensity in their eyes. Just try to avoid the heavy squinting where the subject's eyes disappear into small dots. It's uncomfortable for them and it makes for an unflattering portrait.

Afternoon works well for this bounced-light effect, because the vertical walls can catch the sun at the best angle. Not much light will bounce off

walls at noon, but after 3PM the angle of the light is perfect for bouncing off walls.

Image **6-4** was taken at about 3:00PM, which accounts for the slightly higher angle of light. The sunlight bounced off the second-story window of an old building to light the model as she stood in the shade at ground level. The window was dirty and scratched, which helped to produce a soft light. The effect is subdued—directional, but without too much contrast.

Shooting in a downtown location in the morning or evening is great for finding natural reflectors. Image **6-5** was done about an hour before sun-

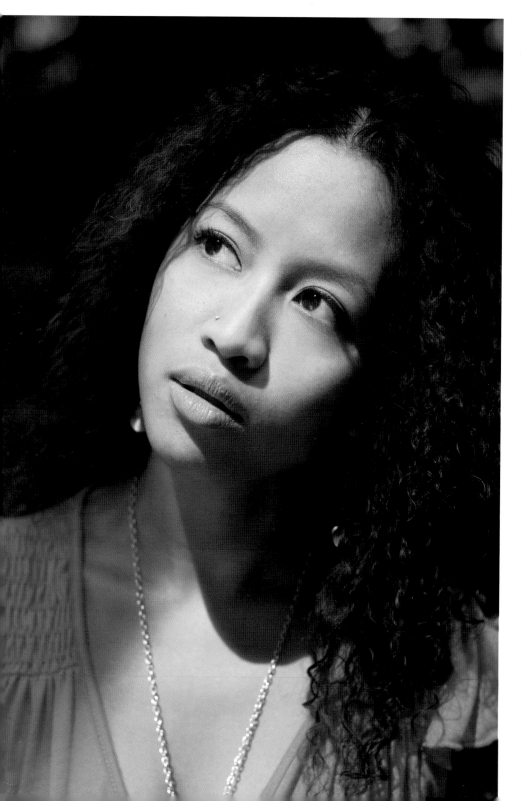

6-4. The model stood in shade as sunlight bounced off the second-story window of an old building. The scratched window helped diffuse the sunlight, creating a softer quality of light.

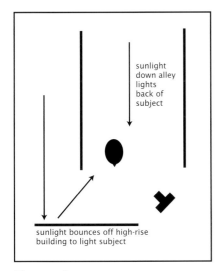

Diagram 9.

6-5. Sunlight lit the subject's back and shoulder directly. Bounced sunlight from a high-rise building across the street lit her face.

set. Sunlight poured down an alley and lit the model's left shoulder. It also lit the high-rise building that was across the street—a natural reflector! This made the high-rise one big, soft light source. It looks like two strobe lights were used on this shot (one for the face and one for the left shoulder), but it is just direct sunlight and bounced sunlight (diagram 9).

6-6 (left). The unusual light patterns on the buildings are a result of bounced evening sunlight from a skyscraper. Photograph by Jennifer Sliker.

6-7 (below). A large white wall to camera left bounced soft light into a large area. Large walls will light large areas.

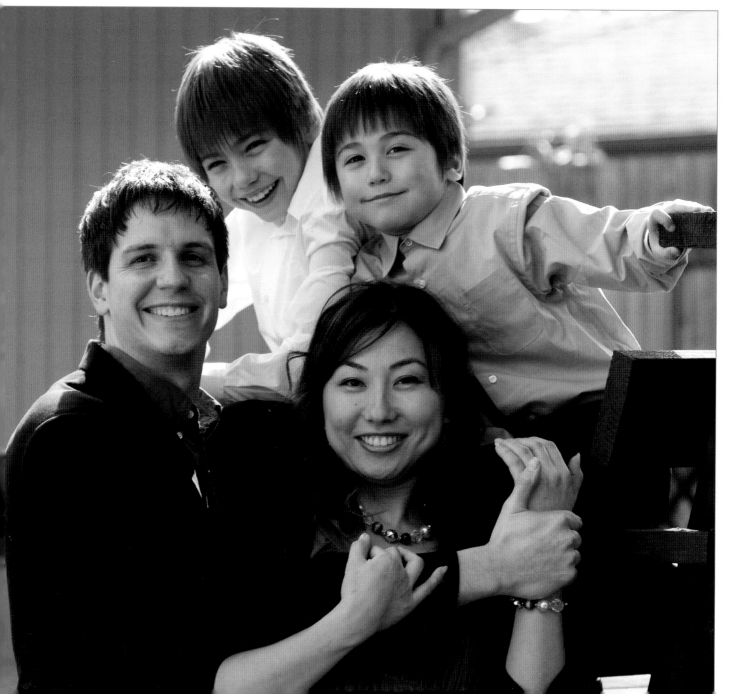

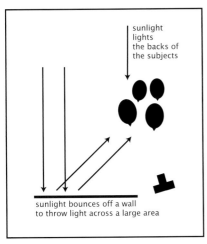

Diagram 10.

People are not the only subjects that look good with bounced light. The buildings in image **6-6** were backlit by the evening sun. The patterned light on their front side was from sunlight bounced off the windows of a skyscraper directly behind the camera position. Bounced light can take on so many different qualities, depending on the surface that the light is bouncing from.

Image **6-7** and diagram 10 show another example of a natural reflector. This one was found in a backyard. The afternoon sunlight backlit the subjects and also bounced off a large white wall to camera left. Bounced light throws light out into a big area, so it's great for groups and subjects that need room to move (*e.g.*, kids, animals, dancers, athletes). It also gives you the ability to have consistent exposures in a large area. The larger the surface reflecting the light, the larger the area it will light.

A natural reflector can be a small object, as well. In this case, it will reflect light into a small area like a mini-spotlight, which can be used to create drama. In image **6-8**, the girl held up a leaf to bounce the sunlight that

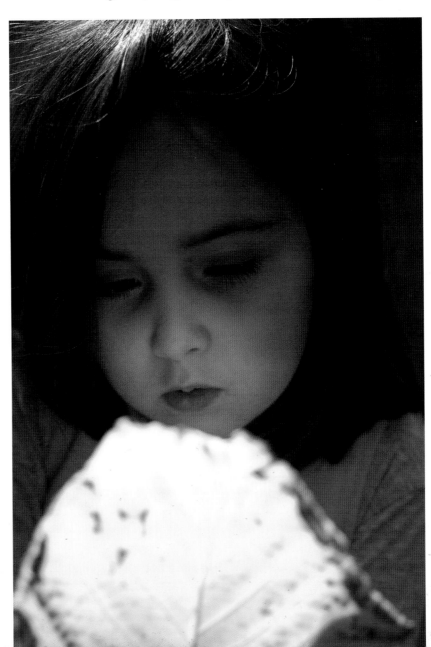

6-8. Small objects, like the leaf the girl is holding, can be used as natural reflectors. Photograph by Jennifer Sliker.

came from behind her onto her face. The reflected light is directional and soft.

At the Mall

The mall is a great place to have your picture taken, right? In one of those photo booths, right? Or that portrait studio that uses the same background and lighting for everyone? Those places are fine and do what they do perfectly well, but to make distinctive shots for yourself just look for one thing: a natural reflector. In this shot (**6-9**), sunlight came from a mall's skylight and bounced off of the floor, creating a blown-out rectangle of light.

The ambient light in the mall provided soft fill light (you can see it light the top of her head). But the natural reflector on the floor added contrast that the ambient light alone would not have. (To prove we were in a mall, there are cups from Jamba Juice and Starbucks on the floor, two companies whose products I enjoy and use to help fuel my photography). Notice how the reflection off the floor produced great catchlights in her eyes (**6-10**).

Be careful when working with a strong light source from below the subject, whether it's direct or reflected. It could give the subject a ghoulish look—like from a bad 1950s horror movie. Now, that may be what you're into, but I usually try to make my subjects look their best. A simple solution is to have your subject tip their head down toward the light from below. That's exactly what I had the subject do in the mall images.

6-9 (above). Sunlight from a skylight hits the floor at a mall—a natural reflector opportunity!

6-10 (facing page). The bounced light off the floor added some much-needed contrast to the ambient light in the mall. When using a significant amount of light from below the subject, have your subject tilt their head toward the light to avoid "monster lighting."

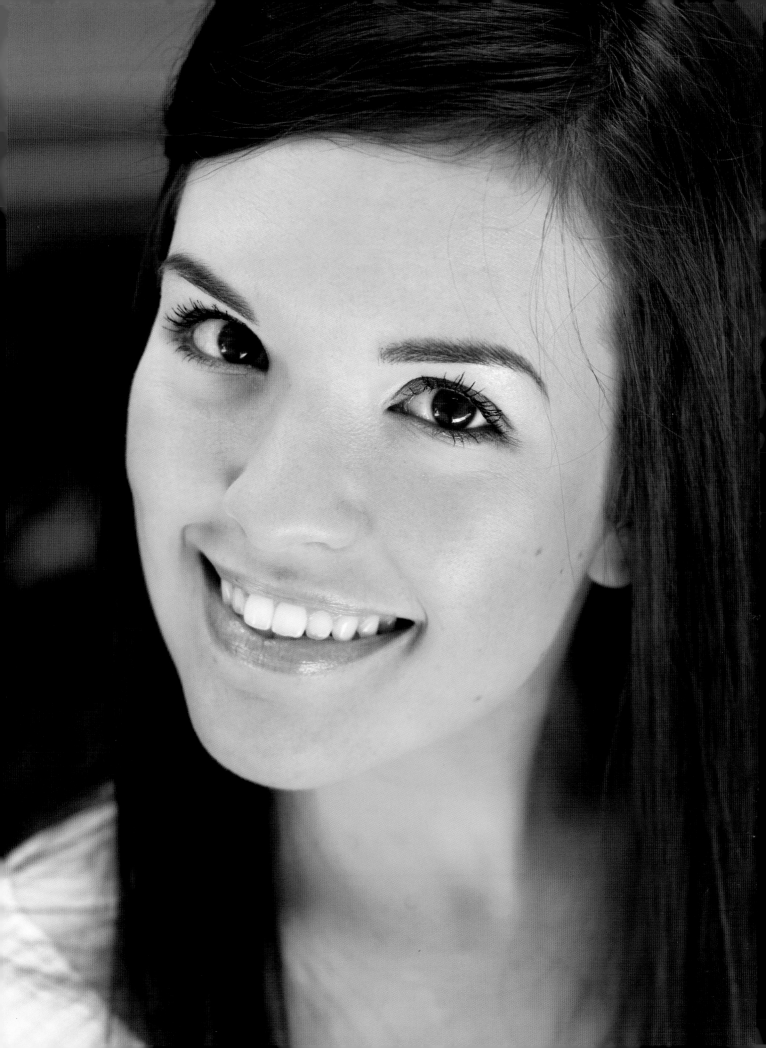

The Color of Natural Reflectors

Now, let's look at some examples of shots done with and without a natural reflector. In the first shot (**6-11**), the model stood next to a metallic light pole (that's what his arm is resting against). The shiny silver surface of the pole reflected light back onto the shadow side his face. But there's also another natural reflector at work here: his yellow shirt is bouncing light onto his face, as well. The combination of the two reflectors bouncing light into his face creates an effect that is similar to using one of those round, collapsible silver/gold striped reflectors. This really warms up the skin tones nicely. The second shot (**6-12**) was done without any natural reflectors.

6-11 (left). A metallic pole (to camera left) and the subject's yellow shirt combine to bounce warm light onto his face and eyes.

6-12 (right). Without any bounced light, the shadows are much darker and the skin tone is cooler.

The difference is noticeable. The shadow side of his face is darker and his skin tone is not as warm.

So why not just use one of those collapsible silver/gold reflectors instead of hunting for natural reflectors? You can use either one—in fact, I encourage you to purchase one of those reflectors. They're convenient and inexpensive. However, you will also have to have an assistant hold the reflector or mount it on a stand yourself and pray that it's not a windy day. I prefer working with natural reflectors because they train your eye to see the light that is around you and give you confidence to work spontaneously. And they're already set up.

Keep in Mind

1. Bounced/reflected light is great light for portraits. It's softer than direct light.
2. Looking for natural reflectors will develop your eye to see light.
3. Morning or late afternoons are good times for finding natural reflectors. The lower angle of the sun helps to bounce light off walls and buildings.

> Use caution when working with bounced light from the floor or ground.

4. Reflected light can be intense. Don't make your subject face a bright wall if it makes them squint.
5. Big walls reflect a lot of light and can light a big area. Use this to your advantage when photographing groups or subjects on the move (kids, animals, athletes).
6. Think small! Look for small objects to reflect light into a small area. They act like mini-spotlights.
7. Use caution when working with bounced light from the floor or ground. Avoid the ghoulish look by having your subject tilt their head down toward the light.

Finding Light

*T*his chapter will challenge you to find the "buried treasures" of light-
ing. These are what I call Pockets of Light or Sun Spotlights. Nor-
mally we walk right by them, but I would like to invite you to slow down
and find them. "Okay," you say, "What the heck are they?" They are areas
that seem to have their own special highlight on them, a
spot where a little kiss of light seems to be telling a story.
It's a place that is lit with different light than anything
around it, almost like a big stage light was put up in a tree
to light the scene. This may sound like I want you take a
trip to never-never land (Don't go! The food is terrible.),
but what I really want is for you to find these spots close by in your neigh-
borhood. It could be the morning sun that comes in your window to light
your spouse doing the *Times* crossword. It could be the lamppost on the
corner that illuminates the pedestrians on the sidewalk at dusk. It could be
the last bit of sunset light on the wall of your office.

> What I really want is for you
> to find these spots close by
> in your neighborhood.

Dappled Light

One place to find a Pocket of Light is under some tree branches in an area
of dappled light. Now, every bit of advice I've ever heard about making
portraits has said to avoid this type of light. It leaves unappealing lines on
peoples face and creates high-contrast edges. Shooting portraits in dappled
light should be avoided at all costs. End of story, right? Well, all of that
can be true—if you choose the wrong type of dappled light. If you choose
the right kind, however, you can make beautiful portraits that are reminis-
cent of Hollywood portraits from the 1930s and 1940s.

When working with dappled light, you need to find areas with soft-edge shadows—and the best place to find soft-edge shadows is where there are trees. When shadows come from distant objects, such as tree leaves and branches that are perhaps twenty feet or more from the subject, the shadows created have a very soft edge. This is good. On the other hand, if the shadows come from leaves that are very close to the subject, then the shadow edge will be very hard and crisp. This is bad.

Let's do an experiment right now. If you are reading this page by a table lamp or in sunlight, hold your hand an inch over the page to see the hard-edge shadow formed by your hand. Now move your hand closer to the light to see how the shadow edge becomes softer. This is the same shadow effect that leaves and branches give when they are close or far from the subject. (*Note:* This experiment won't work under diffused light, since the light source is too large—but you won't be able to work with dappled light on an overcast day anyway.)

> The key to working with dappled light is patience, on your part and your model's.

The key to working with dappled light is patience, on your part and your model's. When you find some nice soft-edge shadows to work with, you will notice that the light acts like a spotlight; it will light only small areas. If the subject moves slightly, it can change the whole look of the shot. Where light may have been lighting their eyes a few seconds ago, it may now be lighting their ear. What happened? Chances are that your subject moved. Carefully coax them back to the original position (offers of money usually do the trick). This type of "spotlighting" can test the patience of your subject. Get them in a comfortable pose or position that they will be able to hold for a while, because you don't want them to move out of the light. Reassure them by telling them that Cary Grant and Ingrid Bergman held their poses, too.

Morning and late afternoon are the best time to shoot with dappled light, mainly as it relates to the angle of the light hitting your subject. When the sun is lower in the sky, the light will come at your subject's eyes more directly and produce a nice catchlight. If the sun is too high in the sky, your subject will have to turn their head skyward for the catchlights to be seen from the camera.

It's possible to get different contrast effects in your shots with dappled light, depending on the where you are shooting. I have found that shooting in an urban environment works best for getting extra fill light into a portrait, because a lot of light bounces off pavement and buildings to fill in the shadow areas. If you want more drama, work with dappled light in the forest. The dark forest floor and surrounding trees do not bounce as

much light as a city environment. Your natural sun spotlights will create a higher contrast between highlight and shadow in the forest, adding drama to your portraits.

Visual High Points

Here's an important idea: an interesting portrait, or any photograph for that matter, has visual high points and other less important areas. Important parts of the subject are emphasized with light, while less important areas are kept shaded. Beginning photographers often make the mistake of lighting their subjects too evenly. That may work for shooting evidence and medical photos, but it makes for a boring portrait. Taking a cue from the classic Hollywood glamour portraits, where shadows and highlights created mystery, drama, and visual high points, you can look for where the sun creates its own Hollywood sets—right in your own neighborhood.

Do some research on the famous Hollywood glamour photographers. George Hurrell was a master at creating beautiful interplay between highlights and shadows. Also, the work of Laszlo Willinger, Ernest Bachrach, and C. S. Bull should inspire you to look for your own natural Hollywood lighting.

Here is a series to show you the possibilities that exist right in your neighborhood. In this scene (**7-1**), there is an area that is a Pocket of Light.

7-1. A Pocket of Light exists just left of the doors.

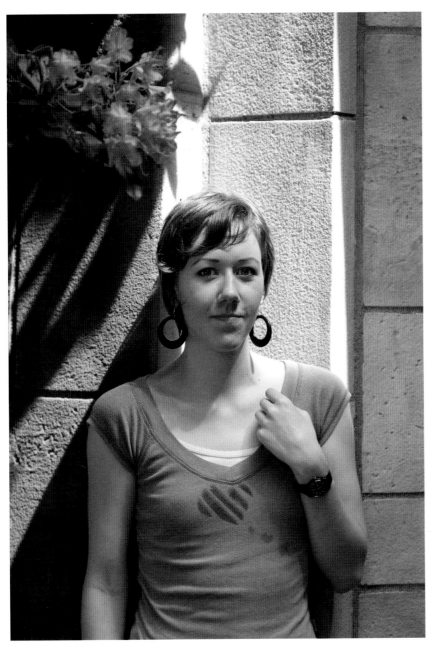

7-2. Hard and soft shadows are formed by objects that are close or far away.

Can you find it? It's the area of sunlight just to the left of the doors. On sunny days, look for these little spotlights created by the sun. They make for excellent portrait opportunities, but they will require a bit of work from you and your subject.

Look for pockets of light that are about half the size of your subject. This will allow the light to create highlights in the areas that are getting direct sun but also allow the light to fall off into the darker, shaded areas. In this case (**7-2**), the subject was placed at the wall near the spotlight effect of the sun. The sun lit her left shoulder, but her face was just at the edge of the shadow.

When the sun creates spotlights like this, it also creates shadows of various shapes, forms, and angles. For example, shadows from objects closer to the subject will have crisp edges, while shadows from objects further away will have softer edges. Notice the two types of shadows in this shot. There is a crisp shadow next to the model's left shoulder from the overhang of the doorway. The shadows from the flowers also cast crisp shadows. But the subtle shadows on the left side of the model's face are from the top of a plant to camera right, which is about twelve feet above the model. These will come into play in the next shot.

Reviewing image **7-2** a bit more, notice how your eye keeps looking to the back wall, because it's the brightest area in the shot. It's a nice wall—but this is a portrait of her, not the wall. Changing the point of view to take advantage of the shadows (**7-3**; next page) helps to take some of the attention away from the bright wall. Also, we can really start to see the potential of the soft light and shadows from this direction. Moving in close to the subject has helped, as well.

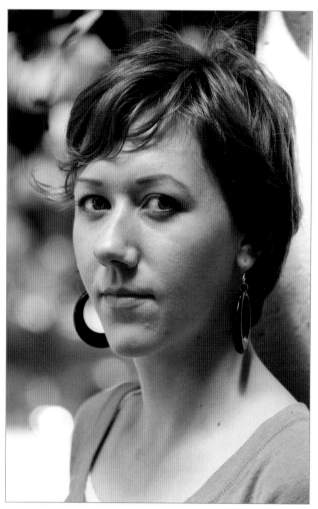

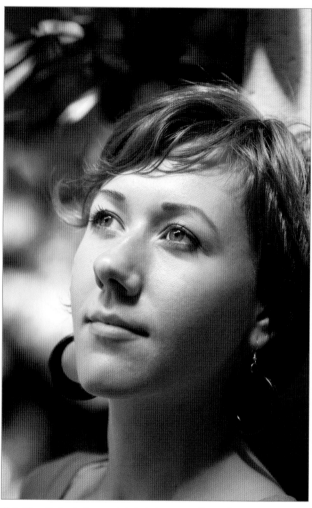

7-3. A different point of view takes the emphasis off the bright wall.

7-4. The light is just a bit brighter on the subject's forehead and eyes than on her chin and neck.

Additionally, setting the aperture at wide open, to create a shallow depth of field, helped to throw the background out of focus and keep the emphasis on the subject's face. It's not necessary to have a lot of depth of field when doing a portrait. A shallow depth of field keeps the emphasis on the person you are photographing while blurring any distractions in the background. In fact, you need just enough depth of field to get the face in focus—and sometimes it's even enough to just have the eyes in focus. Further still, sometimes it's enough just to have the eye that is closest to the camera in focus. If the forward eye is in focus, then your portrait is "in focus."

For the next shot (**7-4**), the model was directed to turn her head up to the light. This produced some nice catchlights in her eyes. (Because of the soft-edge shadows, the sun was not too bright for her to keep her eyes relaxed. Squinting eyes don't make for good portraits!) Notice how the light

is subtly brighter on her forehead and eyes than on her chin. This is the subtle shadow edge of the plant twelve feet above her. It can be difficult to work with these sun "spotlights" since they don't stay static. They move as the sun moves. Your model will have to be patient, too, as you instruct her or him to angle their face to the best light-catching position.

Lastly, the image was converted to black & white (**7-5**) as homage to the great George Hurrell. Keep your eyes open to find these sun spotlights or Pockets of Light. Whatever you want to call them, they're out there.

7-5. Converting the image to black & white shows the soft spotlight effect more dramatically.

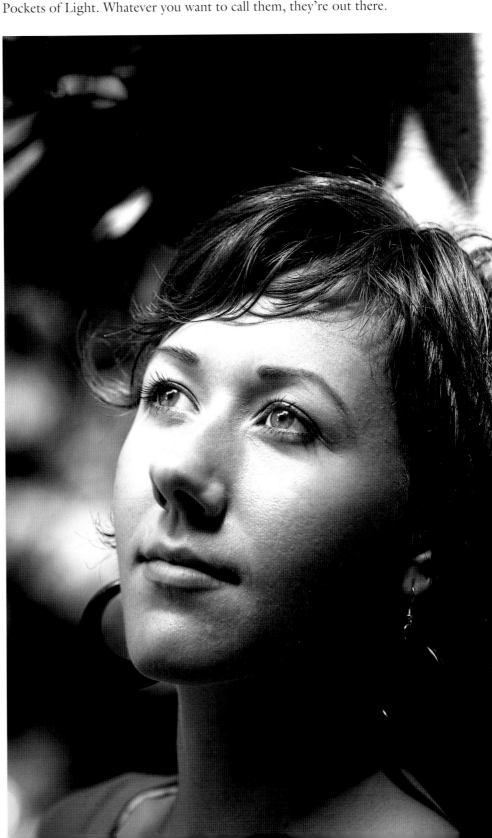

In our next series of dappled light shots (**7-6** and **7-7**), morning sunlight spilled through tree branches and leaves. The morning sun, as it passed through the leaves, was not difficult for the model to look toward. (Squint-free light!) A pleasing soft spotlight was created on her face from the soft-edge shadows. The light fell off toward her hair and right shoulder, keeping the emphasis on her face. Since the tree branches and leaves were about fifty feet away, the shadows formed were very soft. If you aren't sure where to find these soft-edge shadows in the area you are shooting in, just look at the ground or a wall. Chances are the sunlight will be making both soft and hard shadows from different branches and leaves at varying heights and it will show on these surfaces.

7-6 (facing page). Light through the branches and leaves of tall trees, located fifty feet from the subject, created very soft shadows.

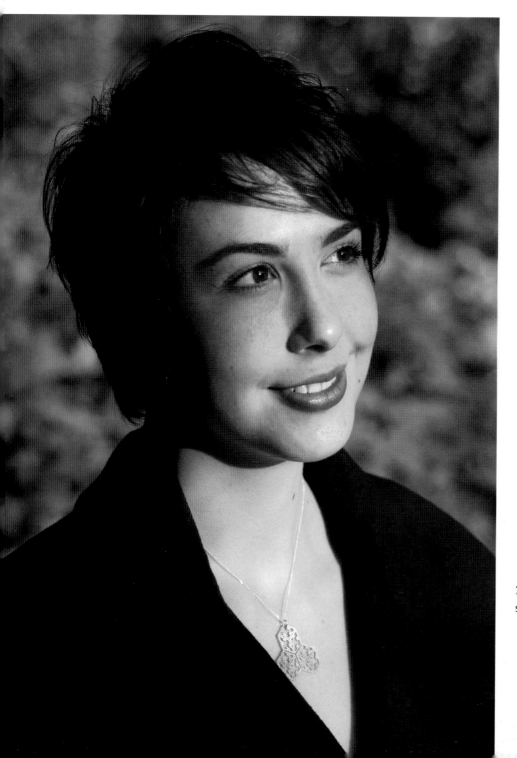

7-7 (left). The subject was positioned so her face and necklace were lit.

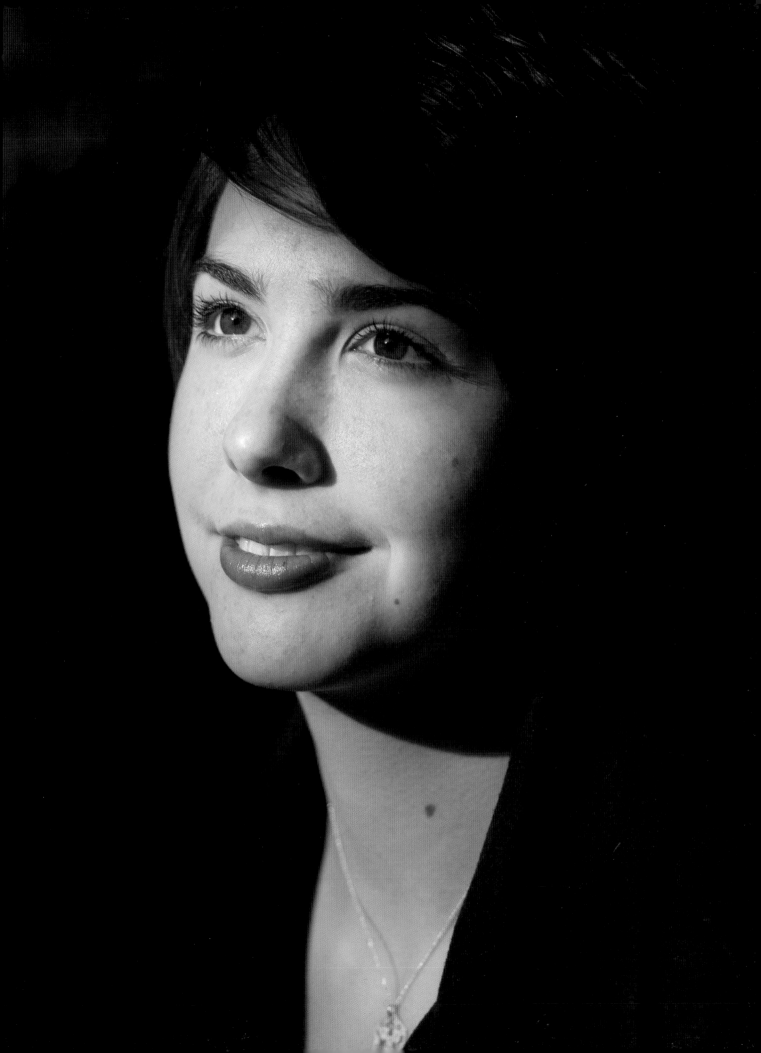

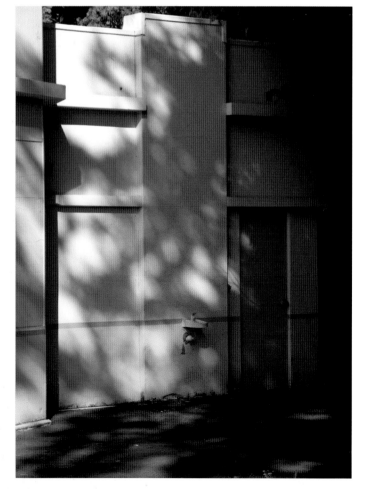

7-8 (top, left). This is a combination of hard and soft shadows from leaves and branches at varying distances from the wall. This would be difficult lighting for portraits.

7-9 (top, right). Consistent soft-edge shadows are better.

7-10 (left). Sun spotlights of various sizes, all with soft-edge shadows, offer many possibilities for portraits.

Finding the Right Shadows

Image **7-8** is an example of morning sunlight making combination shadows on a wall. There are soft-edge shadows combined with hard-edge shadows due to the varying distance of the leaves and limbs from the wall. Although this is an interesting pattern on the wall, it would be a difficult portrait lighting situation. The shadows would be too chaotic on your subject's face. The wall seen in **7-9** is a better choice, since all of the shadows are consistently soft-edged.

When it comes to shadows, **7-10** shows the best wall of them all. The sun spotlights are of various sizes, giving you many options. You could just spotlight your subject's eyes if you were doing a tight headshot. You could spotlight your subject's head if doing a half-length shot. Or you could spotlight your subject's head and shoulders if doing a three-quarter-length shot.

It's possible to soften dappled light even further by using some diffusion material. For image **7-11**, the subject stood next to a window that had a white translucent window blind. It was a natural-colored, lightweight fabric. Dappled light from late afternoon sunlight lit the window blind from behind, creating little spotlights all over the blind. As long as she stood close to the blind, the spotlights worked to highlight different parts of her face and hands. If she had stood further away, the blinds would have just

7-11. Dappled light was diffused through a window blind, creating soft spotlights.

acted as an overall soft light source. This same effect can be achieved outdoors as well by using dappled light and some diffusion material placed close to your subject.

This shot is high contrast, because there is no fill light. No reflector was used and the room was relatively dark compared to the window light. As a result, no light filled in the shadow side of her face. Natural light can do amazing work. A shot like this would be difficult to achieve in the studio: soft, directional light with subtle spotlights and dramatic contrast. But here it is for you, right in the living room on a late sunny afternoon.

Photographing children in dappled light is challenging but worth it. Kids are always moving so you can't get them to stop at the right spotlight area. In this shot (**7-12**), I initially tried my luck by placing the toddler so that her head was in a pocket of sunlight, but she kept moving in and out of it. Then I moved her back a bit so that the spotlight hit at her feet instead. I thought her feet would make for a great visual high point and were less likely to move. When she grabbed her feet with her hands and smiled, it all came together. Visually, you look at her face first and then at her tiny hands and feet.

7-12. Dappled light created a visual high point where the toddler grabbed her toes.

Evening Light

This shot (**7-13**) was done in the early evening, just before the sun disappeared behind some homes across the street from the shoot location. The last remaining sunlight came from over my shoulder to light the subject. This is an ideal time to find light and make great portraits. The sun is less intense and has a softer quality at this time of day, making it easier for the subject to look toward it. Try to catch the sunlight as it shines almost horizontally. The long shadows cast by buildings or distant hills at this time of day can be advantageous. Position your subject so that their face is in sunlight but their body is in the shadow of a building. You won't have much time to shoot, but I guarantee you will get some nice shots.

7-13. Evening sun, just before sunset, has a softer quality that is easier for subjects to look toward.

Image **7-14** is another example of the evening sunlight doing its magic. The shadows from the rope ladder, which the subject stood on, framed her face perfectly as the sun poured through to make a nice spotlight effect on her face. At this low angle, the sun isn't too intense for her eyes. She squinted slightly but, for the most part, her eyes were relaxed. Be aware of where the shadows fall on your subject when you look for these pockets of light. This shot would not have worked nearly as well if the shadow across her neck were coming across her mouth instead.

Finding Light in Unusual Places

Pockets of Light can exist in unnatural places, too. And what's more unnatural than a mall? Image **7-15** is an example of finding some studio-quality lighting just by walking through the mall. The model here was lit by one of those backlit store directories that you encounter when you first enter the mall. These are also called duratrans or translites and you can find them in bus shelters, too. To me, they are like having a large studio softbox on location without all the light stands, strobes, extension cords, assistants, permits, security guards—well, you get the point.

This was a big, soft, and very frontal light source. So frontal, in fact, that I was standing in front of it when I took the photo (if you look closely in her eyes, you can see my outline). The light poured around the camera to create smooth texture for her skin. Keep in mind that frontal lighting smooths and flattens whatever is being photographed, while side lighting enhances texture and surface quality.

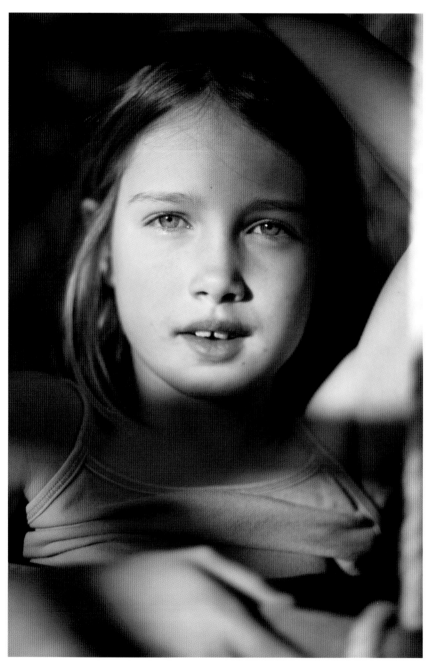

7-14 (left). Evening sun creates a spotlight effect through the shadows of a rope ladder.

7-15 (facing page). "Finding light" in the mall is possible courtesy of a mall directory sign.

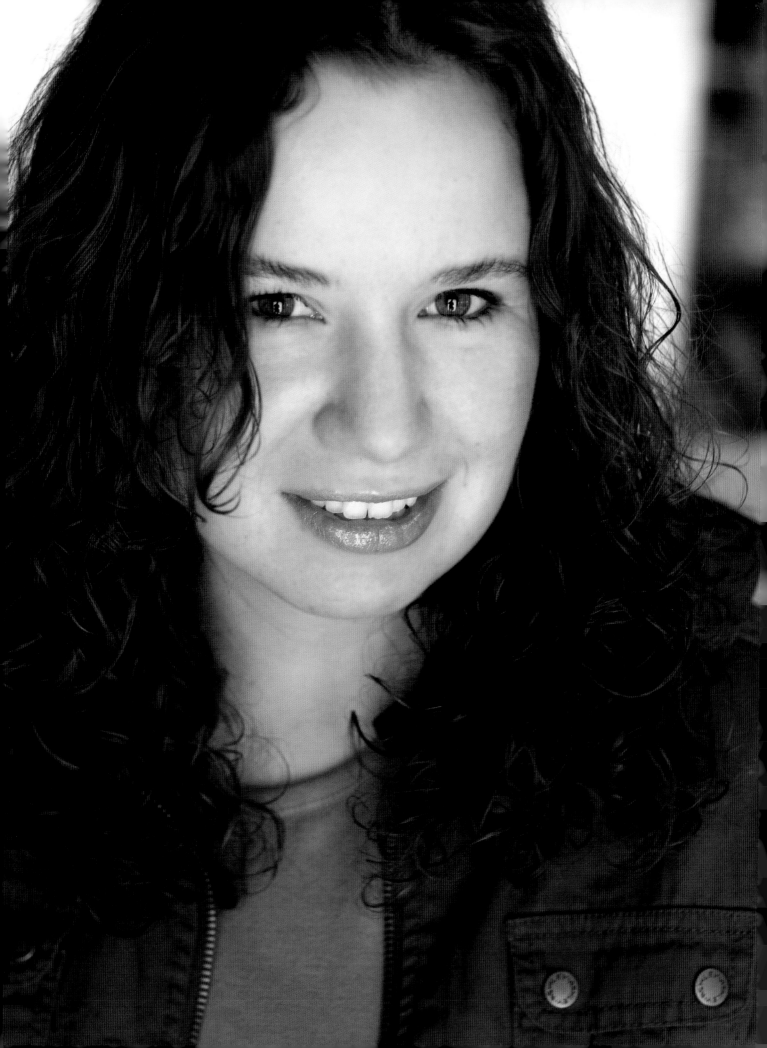

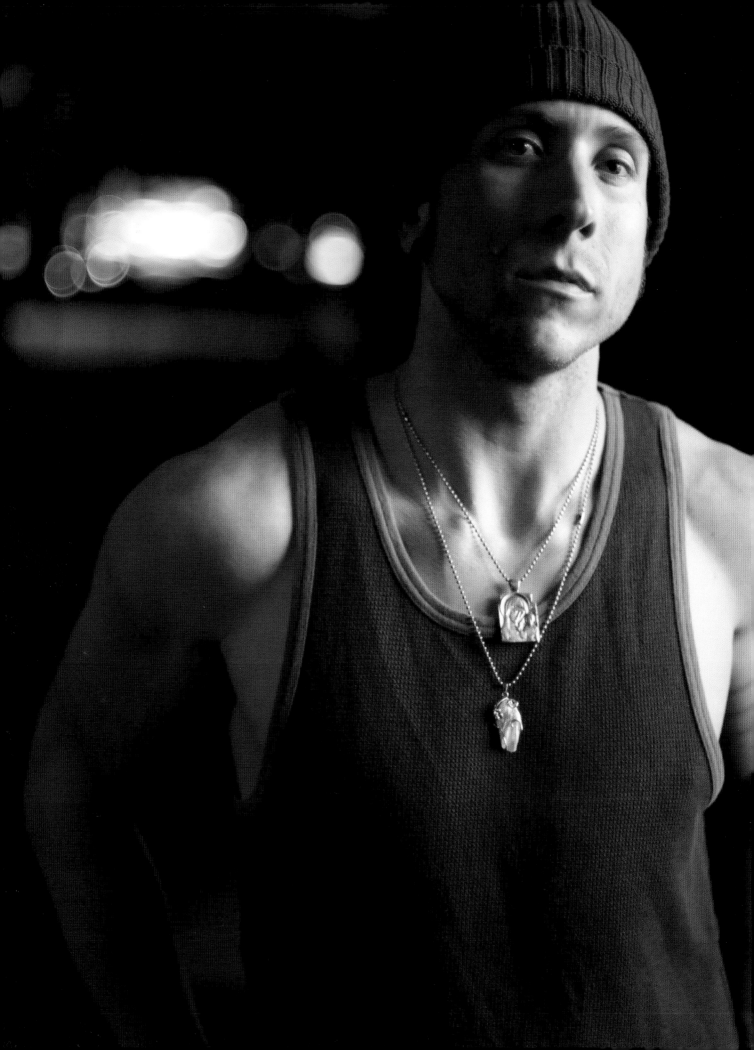

7-16 (right). Street lights from above work well for lighting the human shape and form.

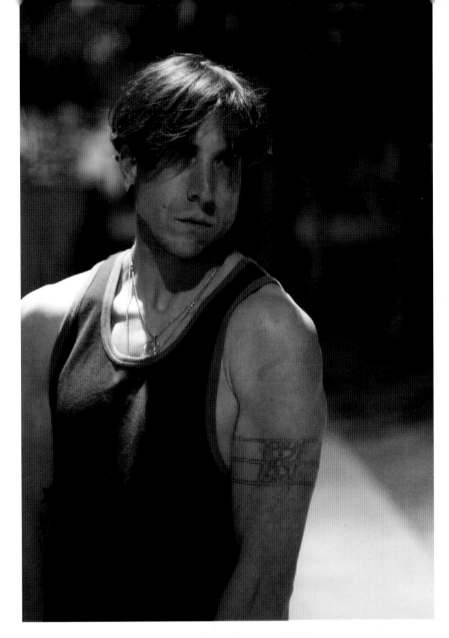

Experiment time again! Try this right now. Hold up a piece of paper to the brightest light source near you. Angle the paper so that the light hits it straight on. The paper appears flat and smooth. Now turn the paper away from the light, so that the light is raking across the surface of the paper at an angle. Now you can see the surface texture and shape of the paper. You can apply this smooth/textured technique to whatever you are photographing. If you want smoothness, keep the light frontal. If you want texture and shape, keep the light to the side. With my photography, I generally use frontal lighting for shots of women and side lighting for shots of men—*but not always.* I may start with this in mind but quickly reverse it if it seems to suit the subject.

As seen in image **7-16**, doing street portraits at night is a great way to find interesting light. You will need a tripod, a shutter release, and a fast lens

7-17 (facing page). Street-level light works best for portraits.

if you have one (*i.e.,* a lens with widest aperture f/1.4 to f/2.8). This shot was done under sodium vapor lamps in an industrial area.

Probably the biggest issue when working with street lights is their direction. Nearly all of them light your subject from directly above. This can be a problem if you are trying to get light on your subject's face. Your subject's neck will get sore quickly if they have to crane their head up to catch the light for every shot. It is better to use the overhead light to photograph body shapes and gestures.

Probably the biggest issue when working with street lights is their direction.

It is possible to find lights at night that will light faces, though. Look for light from storefronts or offices or anywhere else where the light is at eye level. An added benefit of these types of light sources is that they are usually soft and big, a result of the interior fluorescent lights. Image **7-17** (page 104) was done on the sidewalk next to the interior lights from an office building.

Keep in Mind

1. Create visual high points in your photographs by using sun spotlights or Pockets of Light.
2. Use dappled light from soft-edge shadows to create Hollywood-style portraits.
3. Use evening light. It has a softer look and is easier for the subject to look toward.
4. Find other unusual sources of light—street lights, storefront lights, headlights, flashlights, Christmas tree lights, flashlights, etc.

Composition

An eye for good composition can be developed with practice and by learning some basic rules. For the portrait photographer, creating an interesting composition of someone can enhance what is being said about that person. At this point in the book, you have a better understanding of how to use light to your advantage and have developed your eye to "see" light. This is important because light, too, can be used as a compositional element. Armed with a solid understanding of light and composition, your photography will improve quickly.

Frames

When it comes to placing your subject in a setting, you should keep in mind the question, "How can I frame them?" Use elements from the foreground or background to create a visual frame around your subject. These will keep the viewer's eye from wandering and keep their interest on your subject. These types of frames can add context to the story of the image, as well.

When the subject is placed at the center of the frame, the viewer's eye is forced to the middle. In this shot (**8-1**; next page), the stacks of books and the window in the background frame the subject and seem to box her in, adding to the claustrophobic feel of the composition. The symmetry also adds to the infinite feeling of the shot. I would like to caution you against making your human subject completely symmetrical within the symmetrical composition. Letting the human body take a natural shape is a good contrast to the surrounding rectangular shapes and creates some visual interest.

> An interesting composition of someone can enhance what is being said.

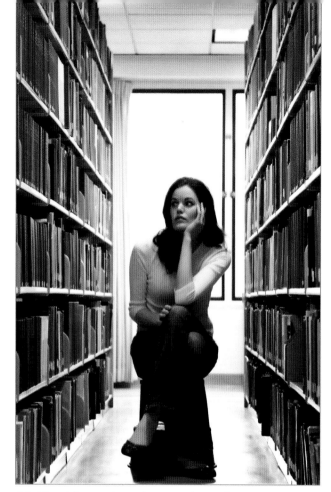

8-1. Visual frames keep the viewer's eye focused on your subject.

8-2. The subject is framed by foreground and background elements and also distinguished by being the brightest object in the image.

Think of the human body as the letter S at the center of a series of rectangles. This is more interesting than another rectangle surrounded by rectangles. Patterns are more interesting when there is a distinct shape that stands out from them.

Of course, frames don't have to have a rectangular shape. Any shape can be used to frame the subject. In image **8-2**, diagonal lines in the foreground and background, along with the bow, help to frame the face of the subject. The light also helps to emphasize the subject, since the brightest area of the image is at the subject's cheek.

The Rule of Thirds and Power Points

The Rule of Thirds states that the image you see when you look through the camera's viewfinder can be divided into thirds both horizontally and vertically. Imagine a line positioned a third of the way down from the top of the image and another line a third of the way up from the bottom. Then imagine two more lines that are placed a third of the way in from each side of the image. (Basically, the lines form a tic-tac-toe grid.)

Diagram 11. The Rule of Thirds grid with Power Points indicated.

Diagram 12. The Rule of Thirds grid with Power Points indicated.

8-3. Placing the dog's eye at a power point adds a sense of balance to the composition.

Your compositions will improve when you start putting existing lines in your images along one of these imaginary lines. For example, when composing landscape shots, place the horizon line along the lower third or upper third of the frame. For portraits, place the eyes of your subject at the upper third of the frame.

An extension of the Rule of Thirds is the concept of Power Points. These are the points where the lines from the Rule of Thirds intersect. By placing key compositional elements at any of these power points you satisfy a basic human understanding of natural composition. (Ancient Greek scholars studied proportions in the natural world and used these to develop geometrical theories for composition and architecture. Their theories of ratios—the Golden Triangle, the Golden Spiral, and the Golden Rectangle—put in mathematical terms what we all know innately about good composition. The idea of the power point is a simplified understanding of these scholars' theories.)

In this image (**8-3**), the dog's eye is at a power point. This is a natural starting point for the viewer's eye, and the extra compositional space cre-

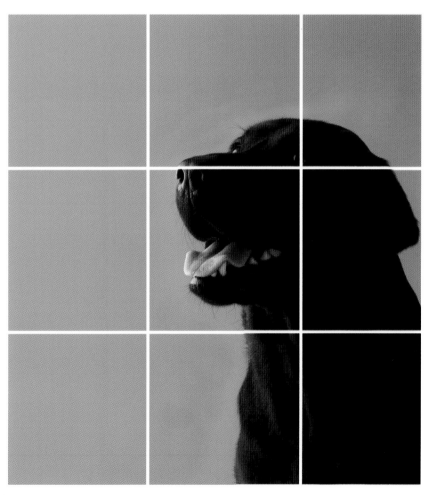

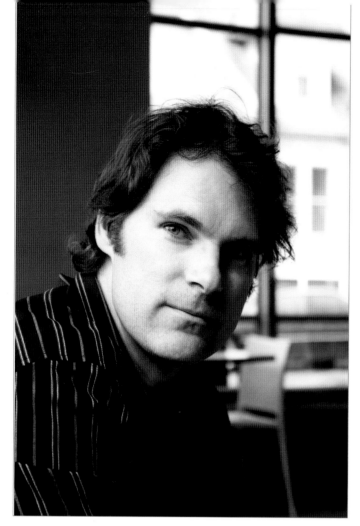

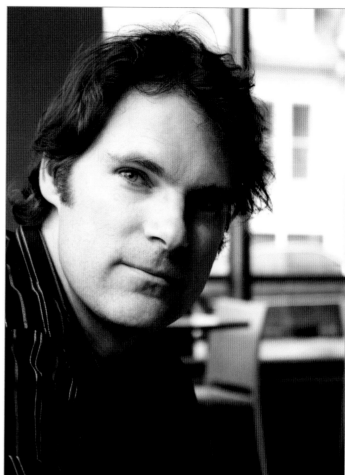

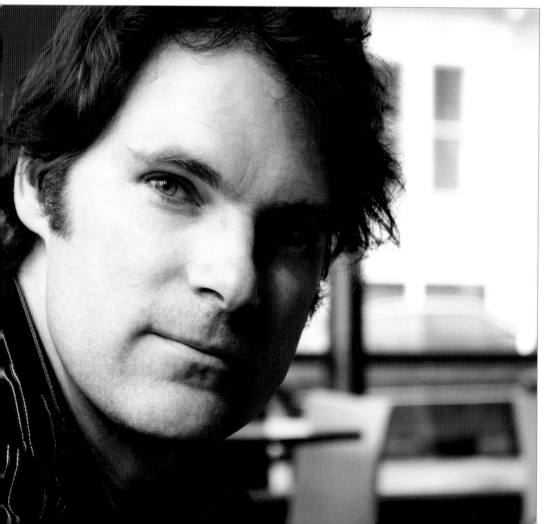

8-4 (top, left). A static composition. The subject is too centered.

8-5 (top, right). Coming in closer and placing the eyes at a power point improves the composition.

8-6 (left). Getting in close creates an intimacy with the subject; and the use of power points and tight cropping adds tension to the image.

ates balance to the "weight" of the dog. Also, in images where the subject is looking off to the left or right, it's a good idea to give them space to "look into." Placing the dog to the right side of the frame gives him plenty of space to look into on the left side of the frame.

Compositional Thought Process

These three images (**8-4**, **8-5**, and **8-6**) could describe the photographer's potential thought process when approaching a composition. The first shot (**8-4**) is what you may see when you first look through the viewfinder. The image is static because the subject is too centered. By moving in closer and placing the subject's eyes at a power point you can achieve a more pleasing composition with either a horizontal or vertical composition (**8-5**, **8-6**).

Now, of course, these last two images (**8-5** and **8-6**) are just cropped versions of the first shot. There are those compositional purists who say you should compose "in camera." I agree. I think it helps to develop your eye for taking better compositions. But don't discard those less-than-perfect compositions. They can be creatively cropped later, and doing so may help you think creatively about compositions for your next shoot.

The Rule of Thirds and Power Points are tried and true methods for creating interesting compositions. But these are rules that are just begging to be broken—and I encourage you to break them. If you feel that your subject would look best centered without any consideration to the Rule of Thirds (or any other kind of fraction, for that matter), then go ahead and make up your own rule, perhaps "The Rule of Bob" (or Lisa or Tom or whoever). But be aware that the ancient Greeks, who came up with these theories, may haunt you. To keep them at bay, occasionally compose a shot using the Rule of Thirds and Power Points.

Leading Lines

When a viewer looks at a photograph, any line or shape that appears in that photograph will guide their eyes. Like reading a road map, the lines and shapes lead to a destination. Lines that lead the viewer toward your subject are called leading lines. In image **8-7**, the camera was placed on the railing

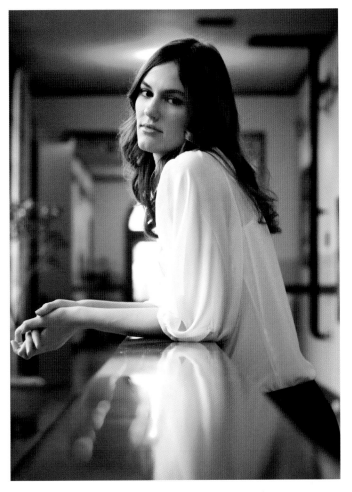

8-7. The railing is a leading line to the subject. Light from the left also leads the viewer's eye to the subject.

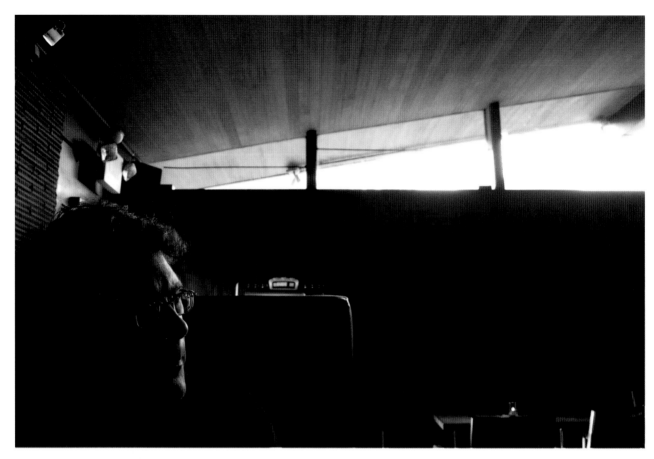

in the foreground. The railing acts as a leading line to the subject. A symmetrical composition was achieved by centering the camera on the railing. Also, the depth of field of the lens helped to isolate the subject from the foreground and background. Lastly, light plays an important compositional element in this shot. The light from a window just out of frame to the left helped to distinguish the subject from the surrounding scene.

In image **8-8**, the viewer's eyes follow the converging lines as they lead to the subject. Then the viewer's eyes follow the subject's gaze out into the open space to the leading lines, and the whole process is started over again. This creates a lot of visual interest. Light, again, plays an important role in separating the subject from the background.

8-8. The subject looks out toward the leading lines that all point back toward him. Photograph by Jennifer Sliker.

Light and Shape

Light has the ability to emphasize certain elements of your composition and show how shapes relate to each other. In image **8-9**, a shaft of sunlight creates a strong diagonal line that mimics the horizontal lines and patterns in the foreground and background. Repeating lines and patterns can enhance your compositions. The shape of the light in this shot stands out among the other shapes since it is the only diagonal in the composition.

Symmetry

A symmetrical composition is pleasing and comfortable to the eye. If it is used too overtly, however, it can be so pleasing and comfortable that it becomes a bit boring and stale. Use symmetry in subtle ways. Using light to create symmetry is one way to add subtle abstraction to your subject. In image **8-10**, the reflection of the subject on the wet pavement adds an abstract element to the shot. The trees in the distance create a subtle symmetry by framing the subject.

Point of View

Changing your point of view can spark your imagination to try new compositions. As image-makers, we tend to view the world through our own comfortable perspective. "If I photograph this subject this way, it should

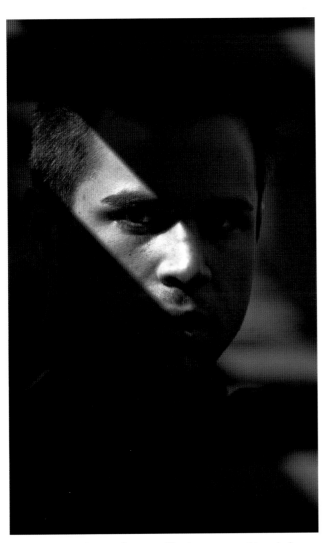

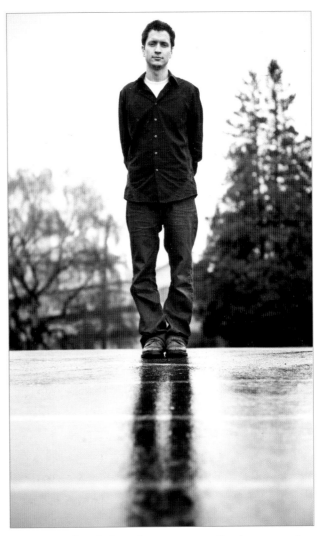

8-9. Light can be used as an effective compositional shape, especially when it relates to other shapes in the image.

8-10. Rainy days help make pavement reflective—a good opportunity for reflections and symmetry.

8-11. A new point of view may lead to unexpected lighting opportunities.

8-12. A brilliant blue sky served as a perfect background to green trees and red-soled sneakers. Photograph by Jennifer Sliker.

8-13. An extreme close up, shallow depth of field, and unusual perspective can make your subject seem to "jump" out of the picture.

turn out looking like this," we say to ourselves before we start shooting. Forcing yourself into a new point of view can fuel your creativity.

The world doesn't only exist at our eye level, five to six feet above the ground. Try seeing the world from your pet's point of view. One of the benefits of a new point of view may be finding unexpected sources of light. I didn't imagine that a white rug could work as a bounced light source until I put the camera on the rug itself to take a shot of the dog (**8-11**).

What would happen if you got down on the ground and pointed your camera skyward? The photographer had to lie on her back to get this shot (**8-12**). The environment above our heads is usually simple and clutter-free, perfect for use as a background. And you may surprise yourself with what you discover from this perspective.

Getting in close to your subject can definitely give you a new point of view and change not only your perspective but your subject's as well. Shots like **8-13** are like a visual surprise for the viewer.

Extra Space

Moving further away from the subject can create visual interest by suggesting scale. Using empty space invites the viewer to use their imagination to "fill in the blanks." Composing the shot in this fashion makes the sub-

What would happen if you got down on the ground and pointed your camera skyward?

8-14 (above). The size of the overcast sky background enhances the shape and color of the subject.

8-15 (left). The hydrant sits in sunlight in front of a shaded gray wall. The solid background space creates tension with the curves and color of the hydrant.

ject more powerful by creating tension or balance. How the subject enters the space and points out to it can further emphasize the compositional elements of the subject itself. In these two examples (**8-14** and **8-15**), the runner's outstretched leg and the top of the hydrant are both pointing toward the open space.

Color and Contrast

The use of color in composition can be used to emphasize your subject. Placing the subject against a contrasting color will make your subject pop off the page. Look for backgrounds that are a complementary color to your subject (as in image **8-16**; next page).

Placing your subject against a monochromatic background is another way to define the form and shape of your subject (**8-17**; page 117). If your

subject is wearing bright colors, they will stand out even more. Monochromatic backgrounds work well compositionally for figure studies, as well. The human form seems to delineate better against a monochromatic background.

Color can be used to support your subject as well. In image **8-18**, elements of the background mimic the color and shape of the subject. This kind of repetition adds balance to the overall image.

Projects

1. Review your old images for composition. Find those images that you think are a bit stale and boring, then crop them so that one of the visual high points is at a Power Point or along one of the lines from the Rule of Thirds. Or, for something more creative, crop the image so that an unexpected part of your subject becomes the visual high point. Hands? Feet? This cropping process will stimulate your mind for subject placement at future photo shoots.

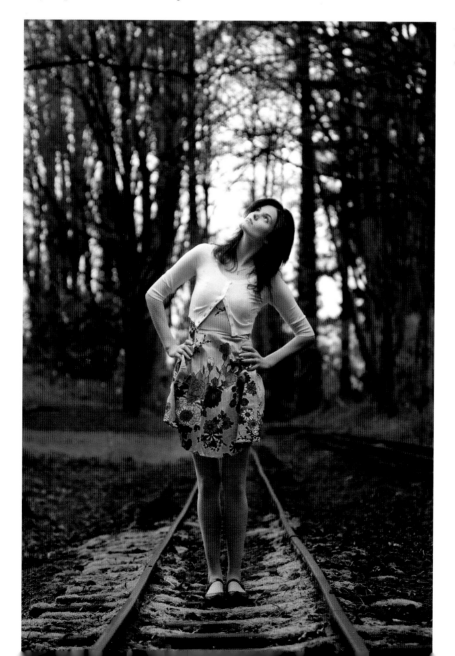

8-16. The verdant background is a good contrast to the model's purple dress.

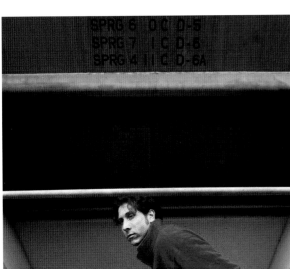

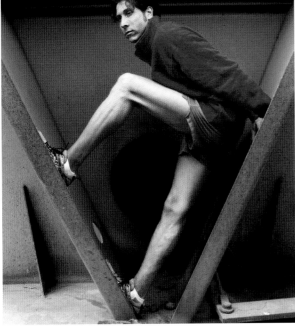

8-17. Monochromatic backgrounds solidify and highlight your subject.

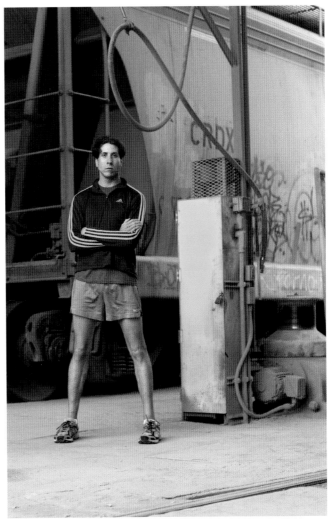

8-18. Shapes and colors that relate between subject and background produce interesting compositions.

2. Frame your portrait subject in a doorway, window, tree branch, or any other object. Do the frames keep the viewer's eyes from wandering? Do the frames add context to the image? Do they tell part of the story?

3. Change your point of view. Spend a day shooting where you do not take a single picture from a standing, eye-level point of view. Get down on the ground or climb a ladder. Shoot straight down to the ground or straight up to the sky.

4. Leave extra space around your subject to create tension or balance.

5. Look for backgrounds that mimic your subject in shape, form, and color.

6. Use a monochromatic background for a portrait or figure study. Your subject's skin tone or colorful clothes can really make them stand out against the background.

Creating Studio Lighting at Home

The number-one question I get asked when teaching lighting workshops is, "How much is all of this lighting equipment going to cost me?" It's true that I am a recovering strobe nerd who has spent thousands of dollars on big power packs and several strobe heads. I still love the power that my strobe packs give me when I need to light a big area or am shooting in a very dark area. But I have been using them less and less these days. I prefer the freedom of working without strobes—the freedom to move quickly, the freedom to change lighting setups more quickly, and the relaxed feeling my subjects get when there isn't a ton of gear surrounding them. If it makes you feel better or more professional to shoot a portrait with three power packs and ten strobe heads then go ahead and do it. Just don't call me to haul your gear.

I prefer the freedom of working without strobes—the freedom to move quickly . . .

So the answer to the question above is, "You don't need lighting equipment to take good portraits." You can get a lot of shots to look like they were done with strobes just by using the lights and windows you have around your house or by buying some inexpensive lights from the hardware store.

Your Thumb, Your Friend

When it comes to photographing someone in your home, you will probable ask the question: Where should I put him or her? My answer is: Let the light guide you. Use an area that has pleasing light to your eye. If you are not sure where that might be or you don't want to move your subject from sofa, to dining room, to barstool, to family room just to find the right light,

9-1. Sunlight from a window creates a high-contrast situation.

9-2. Turning the subject's back to the window created a hair light effect. A lamp was added to light his face.

then use this ancient photographer's secret. Hold your thumb out at arm's length at the position your subject will be at. Observe how the light is hitting your thumb. Your thumb is like a little face. It's round and has a pointy front. Look at the lighting contrast from side to side. Is it frontal or side lighting? Is there enough fill light on the shadow side? Is light from the rear wrapping around the sides of your thumb? Does your thumb look like it's in a good mood today? Take your thumb on a walk from room to room to find the good light.

Positioning the Subject

Image **9-1** was taken in a living room. Sunlight came through a window and created a very high-contrast situation. I actually prefer more contrast when I'm photographing men because I think it gives them a stronger appearance. Although this shot is interesting, it has a bit too much contrast. The interior of the room acts like a big cave and hardly reflects any sunlight back onto the dark side of the subject's face. And there are hot spots on the highlight side of his face. So, in essence, the bright side is too bright and the dark side is too dark. Also the wall in the background is flat and uninteresting. You get the idea.

A quick solution to this high-contrast situation is to turn the subject away from the sunlight so that the sun hits their hair and shoulder, as in image **9-2**. Now the sun acts like a hair light. In this case, a simple lamp (with a daylight-balanced low energy fluorescent bulb) was added at camera left to light his face. You can see the catchlight from this lamp reflected in his eyes. This is a simple reading lamp with a movable lamp head that can be pointed in any direction.

Window blinds form the background for this shot, and by playing around with these a bit I was able to position "the hair light" (the sunlight) exactly where I wanted it to hit the subject. Comparing images **9-1** and **9-2**, you can see that the blinds also are a better looking background than the wall since they create some shape and texture. For a shot like this, it's also helpful to shoot with a telephoto lens and a narrow depth of field. The telephoto lens and shallow depth of field help throw the background out of focus and keep the attention on the subject's face, especially their eyes.

To create image **9-3** (next page), the lamp was moved to camera right and placed a bit higher. This is a classic light placement called

9-3. The lamp was moved to the right of the camera and positioned for loop lighting.

loop lighting. The lamp is placed about 45 degrees to the side of the subject and about 45 degrees up from the subject. It's called a loop light because of the loop-shaped shadow formed by the subject's nose. The sun still acted as hair light on the back of his head and shoulders, although it was toned down a bit by closing the blinds further.

The Living Room Studio

The next sequence illustrates a technique you can use to produce a variety of studioesque (is that a word?) looks right in your own living room. The following sequence of shots (images **9-4**, **9-5**, **9-6**, and **9-7**) were taken on

a cloudy day in a living room with windows on three walls, but they could have been done in a room with windows on two walls, as well. The subject faced a north-facing window. North light is always soft, especially on a cloudy day, so this was a good choice for our portrait. There were also translucent white curtains on this window, which gave more options for controlling the quality of light. It wasn't very bright, so a slower shutter speed was used—along with a tripod.

In the first shot (**9-4**), the translucent curtains were pulled closed behind the camera. This diffused the northern light even more, creating a very soft main light. The window at the back wall let some light in to light the subject's right shoulder and hair. The dark green curtain over her left shoulder was closed to block virtually all of the light from that window.

In the next shot (**9-5**), the translucent curtain behind the camera position was opened up to allow the overcast daylight to light the subject's face fully. Of course, this let a lot more light into the room but mostly just in

9-4. A diffused north-facing window created soft lighting on the subject's face. A window at the far side of the room lit her right shoulder and hair.

9-5. Diffusion was removed from the window, creating higher contrast light on the subject. Doing this added more light to the immediate area at the subject. A faster shutter speed was used to maintain good exposure on the subject. This, consequently, darkened the background.

9-6. The curtains behind the subject were opened slightly to create a hair light effect and lighten the background.

9-7. The diffusion material was added back to the north-facing window, as in the first shot (9-4). A slower shutter speed was used to maintain good exposure on the subject, which lightened the background, as well.

the area of the subject. This affected the exposure, so a faster shutter speed was used to keep a correct exposure on the subject's face. Notice that the background has gone darker now, relative to the subject. The quality of light has changed slightly, as well. It is a bit higher in contrast due to the fact that the diffusing curtain was not used.

For this next shot (**9-6**), the dark green curtains directly behind the subject were opened slightly. You can see them clearly in the shot. This created a hair light on the subject. Be careful about letting too much light in from this "hair light," though; it could cause lens flare. Not that there's anything wrong with that! Just be aware of it (see chapter 3 for more on flare).

For the final shot (**9-7**), the translucent white curtains behind the camera were closed once again. This reduced the light on the subject, so the exposure was changed back to what it had been in the first shot (9-4). Now the background has gone lighter since the overall exposure has increased. And we are back to our softer quality of light on the subject's face. I think this is the best shot of the bunch!

Still Life

Here is another sequence (images **9-8**, **9-9**, **9-10**, and **9-11**) showing the same effect with a still life. The pepper was placed in the corner of a room with windows on adjacent sides. There is a window to camera right and a window directly behind the pepper. There were dark (but not completely opaque) curtains on both windows to help control the amount of light from each window.

For the first shot (**9-8**), the curtains at camera right were opened to light the front of the pepper while the back curtains were closed. The highlights are clearly seen on the front of the pepper.

For the second shot (**9-9**), the rear curtain was opened slightly at camera left. This added more light, overall, to the shot so the camera exposure was closed down (made darker) by one stop. There is now a "rim light" on the pepper (that's what we call a hair light for objects). Notice that the front highlights are darker as well, due to closing the lens down one stop.

9-8). A window at camera right lit the front of the pepper. A curtain blocks the window directly behind the pepper.

9-9. The rear curtain was opened slightly at camera left, adding a rim light and more overall light.

For the third shot (**9-10**), the rear curtain was opened slightly on camera right, as well. This added a second rim light to the back of the pepper. It also added more light to the shot; once again, the lens was closed down an additional half stop and the front highlights were minimized further.

For the final shot (**9-11**), the curtains lighting the front of the pepper to camera right were closed completely and the back curtains were opened completely. This let a lot of light in and the exposure was closed down three stops from the last shot. The pepper is entirely backlit now, creating a near silhouette. The front highlights on the pepper are very subtle now.

So there it is—controllable studio-style lighting right in your own living room. You can control the quality of the light, foreground to background exposure ratios, and the amount of main light and hair light just by adjusting your curtains!

9-10. The rear curtain was opened on camera right for this shot. This added a second rim light to the pepper.

9-11. The front curtain was closed and the back curtain was opened completely. This added so much light to the pepper that a three-stop darker exposure was made.

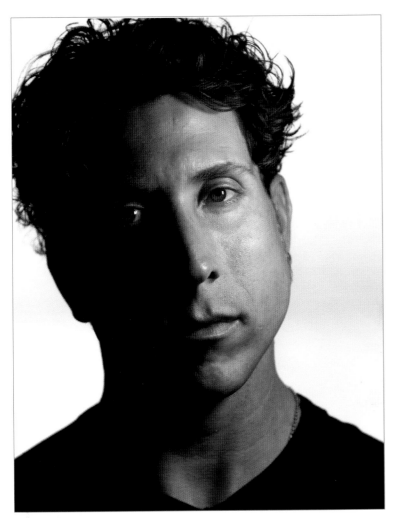

9-12. The subject held a shop light up close to his face. The fluorescent tubes of the light produce a "softbox" look when they are placed close to the subject.

Getting the Softbox Look

Hardware stores are great places to buy useful and inexpensive lights. Look for lights that offer a softer quality. I like the shop lights with fluorescent tubes. They are lightweight and have built-in clips so you can attach them to anything. This shot was done with a shop light that had tubes balanced to 7000 Kelvin. Setting my camera's white balance to "cloudy" produced good skin tones (**9-12**).

Instead of mounting the light for this shot, I had the subject himself hold the light out to the side (it is just out of camera view to the right). The tubes of the light were only about eight inches long but, since they were relatively close to the subject, they still produced a soft quality of light. Remember: the light will get softer as it gets closer to the subject. The effect produced has the look of a studio softbox.

Keep in Mind

1. Position your subject where you can control the light on his or her face as well as the background. Adjacent windows with curtains work well for this.

2. Use your thumb as a test subject to see how light is falling on it. The shape of a thumb is similar to a face.

3. Buy some daylight-balanced fluorescent bulbs to put in an adjustable lamp head. These work well to control the light on a subject's face. Also, get a shop light with long fluorescent tubes to get the softbox look for portraits.

Index